CHIHULY:
AN ARTIST COLLECTS

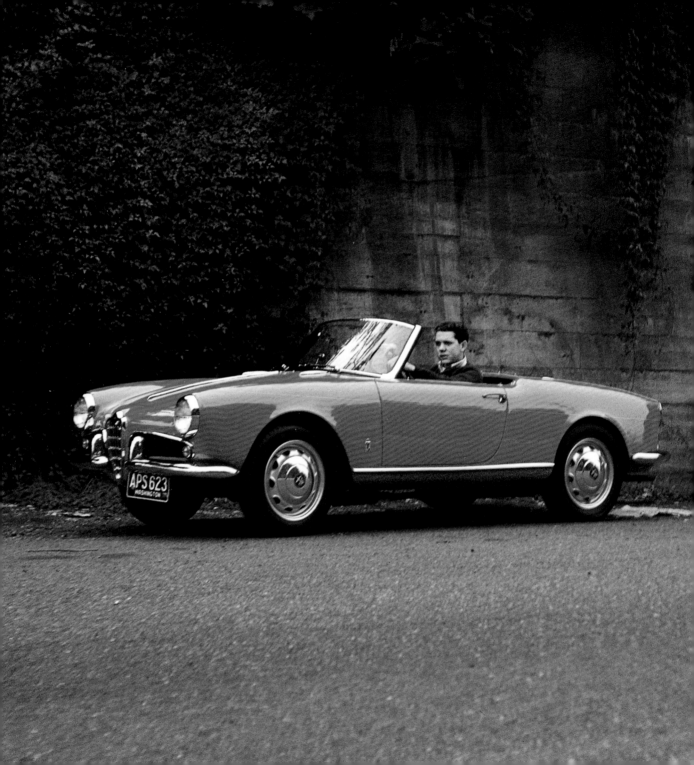

CHIHULY:
AN ARTIST COLLECTS

ESSAY BY BRUCE HELANDER
EDITED BY SUSAN HALL

ABRAMS, NEW YORK

ABRAMS The Art of Books
115 West 18th Street, New York, NY 10011
abramsbooks.com

For Italo

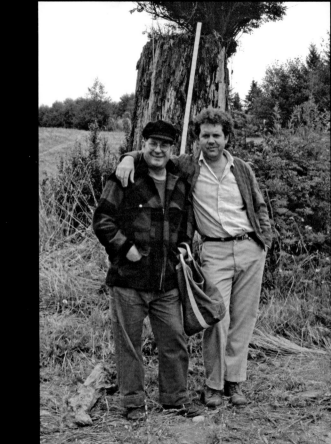

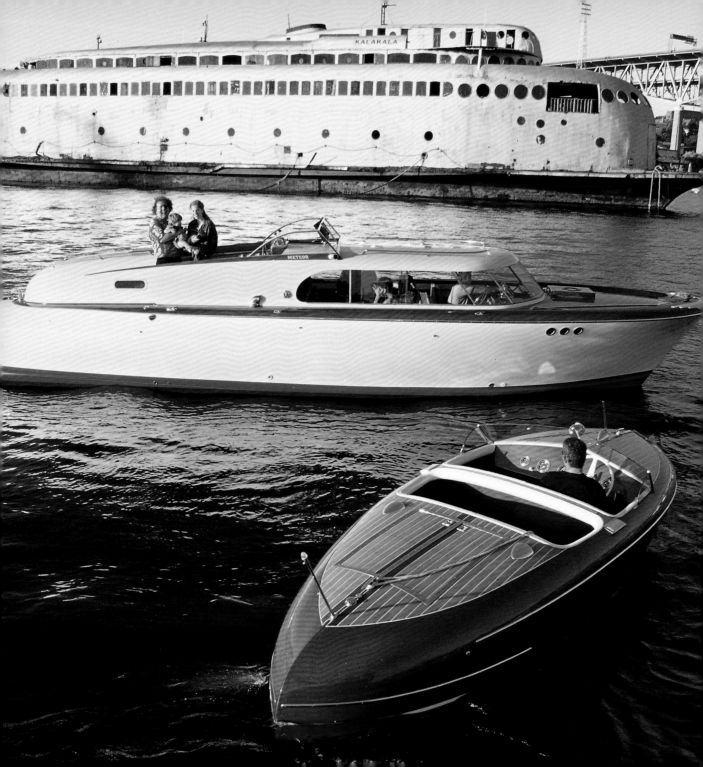

CONTENTS

THE STRENGTH OF A THREAD 10
by Bruce Helander

FEATURED COLLECTIONS 28

DALE CHIHULY 179

COLLECTIONS LIST 180

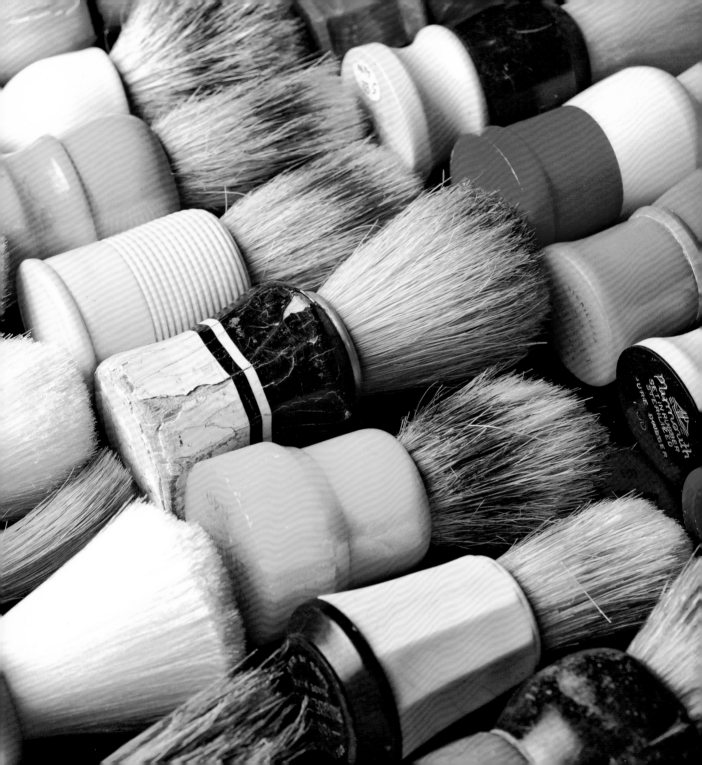

I love to find the beauty
in everyday objects.

—Dale Chihuly

The Strength of a Thread

By Bruce Helander

Someone once said, "If something exists, somebody somewhere collects it." For some of us, an associated guiding principle on this intriguing subject is that if you have more than one of anything with a recognizable DNA, you've got the beginnings of a potential collection, and depending on the degree of your commitment, this habitual activity can develop into an invigorating and lifelong pleasurable compulsion. The first official collector, believe it or not, had wings—but he was not exactly an angel, considering that his modus operandi was to take coveted items from others without their permission. The culprit was the inquisitive, black-and-white-feathered common magpie, who displayed humanlike instincts by spending every day scavenging, assisted by a strategic aerial perspective, for nontraditional nest-building materials such as keys, coins, jewelry, and almost anything else that had a shiny surface: desirable housewarming objects, for a treetop home with a view, that make this seemingly loony bird quite sane and intelligent.

It seems likely that the first objects hoarded by primitive societies filled an intuitive urge to gather outside the homestead, then transport them back inside a man cave to be sorted into categories, either for pure enjoyment or for practical reasons: scallop shells could be used as spoons, feathers as body decoration, and bones as carving tools. Collecting was an understandable extension of evolutionary activity, and whatever the motivation, these early documented procurement practices continued for thousands of years, pushing an ancient custom of salvaging used or found objects (from the French, *objets trouvés*) into modern times, complete with a huge supportive industry composed of antique shops, secondhand stores, flea markets, neighborhood yard sales, eBay, and auction houses that specialize in Americana.

Collecting particular objects, as opposed to works of art, has been a shared passion for artists, as this pleasantly addictive pursuit can become a part of one's temperament, vision, possessiveness, and selective creativity, adding exponentially to the distinct quality of the immediate visual environment.

For a few artists, even centuries ago, obsessively amassing items from nature, such as exotic animal specimens, unusual shells, attractive coral fragments, and other organic shapes, became de rigueur as props in a

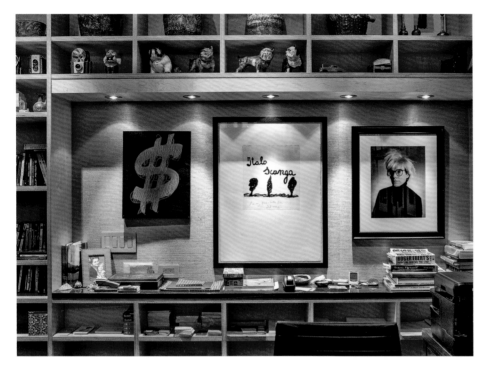

Andy Warhol, *Dollar Sign*, 1981; Italo Scanga, *For My Friend and Brother*; and Christopher Makos, *Andy Glasses Four*, 1986; Dale's home office, Seattle

studio setting, often employed as elements in a still life, complementing an array of man-made items. It's always entertainingly enlightening to see a vintage photograph of an important artist who immersed himself in what he found, bartered, or bought that added personality to his studio and home, while at the same time helping to celebrate the simple things available in life.

It's no secret that many of the world's finest artists also were some of the greatest collectors. Picasso, who is widely credited with originating abstraction, was a voracious collector of objects that appealed to his sensibility and wit and occasionally were utilized in his assemblages (see Picasso, *Bull's Head*, 1942, made from a bicycle's seat and handlebars), as well as a substantial private collection of wondrous works of art other than his own that he thought were enjoyable. In fact, for a time in the 1950s, Picasso was known to stroll around Paris with his then companion, Françoise Gilot, who pushed an empty baby carriage that he would fill with whatever promising bits and pieces he noticed on their walk. Picasso also collected African masks, and their stylized, geometric/cubistic, primitive carved surfaces clearly inspired his own groundbreaking work. Andy Warhol, perhaps the greatest art innovator of the

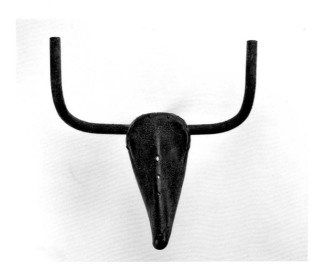

Pablo Picasso, *Bull's Head*, 1942

twentieth century, was the consummate collector of an endless variety of things, from vintage furniture and Art Deco jewelry to cookie jars and watches, among hundreds of other categories. In addition to fabulous objects and period furnishings, Warhol very likely had the largest collection of modern and contemporary art of any artist alive. He never stopped looking for things that he admired, and after his untimely death at the age of fifty-eight, his entire collection, consisting of no less than 10,000 lots, went to auction. It was handled by Sotheby's and took ten full days of constant bidding to complete, with the net proceeds of $25 million (more than $50 million in today's dollars) going to the Andy Warhol Foundation.

In terms of well-known artists as collectors, Dale Chihuly is a champion in this designation,

having the most in common with Warhol and his proclivity for accumulating everything that impressed and enchanted him. They knew each other, and overlapped with multiple acquisitions in some of their favorite categories, such as Native American baskets and blankets, Fiestaware ceramics, cookie jars, and collections of collections. Chihuly traded with Warhol for artworks, and the remains of those transactions also ended up in the Sotheby's sale. Henry Geldzahler was a good friend of both artists, and he wrote the introduction to the Sotheby's five-volume Warhol sale catalog in December 1987 as well as exhibition copy on Chihuly for other shows. It was Geldzahler, when he became a curator of contemporary art at the Metropolitan Museum of Art in New York, who first acquired art by Chihuly—three *Navajo Blanket Cylinders*—for its permanent collection.

Damien Hirst, as one of the most successful artists in the world, also is one of Great Britain's greatest collectors, with vast hordes of objects and paintings. His preoccupation with the precarious balance between life and death has been a constant theme, which carries over into his studio routine. Over the years, Hirst has built a significant collection of natural history objects and taxidermy specimens, scientific and medical tools, pill cabinets, anatomical models, skulls, bugs, butterflies, and flies (which he grows from larvae), among other peculiar stuff that often he assimilates into his artwork. Notable artists who find collecting objects a necessary part of their daily existence also include Peter Blake, a good friend

of Chihuly's who was influenced by Kurt Schwitters's inventive, skillful use of found printed materials for collages. Blake's emphasis was on securing British pop culture icons, vernacular culture, postcards, advertising signs, and curiosities. His famed cover for the Beatles' iconic *Sgt. Pepper's Lonely Hearts Club Band* album, with rows of cutout celebrities, including mutual artist friend and Rhode Island School of Design professor Richard Merkin (back row, center, in bowler hat), was a direct result of incorporating his collecting aesthetic. Jim Shaw, a prominent painter and semi-cult figure who depended on thrift stores as a kid for "weird stuff" and "strange objects," including the largest collection of great "bad" paintings, allowed his interest in the bizarre and goofy to inhabit his work. Besides maintaining a hugely successful career, Dale Chihuly—certainly one of the most pioneering artists of our time—instinctually fits in with this motley crew of famous artists who find collecting and living with objects a very important

and irreplaceable facet of their lives. It is truly a noteworthy achievement that because of Chihuly's unwavering focus, his growing collections of objects likely are the most ambitious in history for an artist.

The adolescent Chihuly unknowingly absorbed early valuable perspectives and a genuine passion for domestic hunting and gathering from his beloved mother, Viola, who was a dedicated gardener, stockpiling plants and household items herself. Growing up in a Tacoma, Washington, working-class neighborhood, he had few opportunities to buy things that were not necessities, but like Warhol, who grew up in a Pittsburgh blue-collar neighborhood, Chihuly made up for it later on!

In the autumn of 1967, while in graduate school at the Rhode Island School of Design, Chihuly met Italo Scanga, a former RISD faculty member who was in town to present a lecture. After the talk, Chihuly introduced himself and invited Scanga to see his studio, in a converted funeral home. This serendipitous introduction and subsequent quick connection of creative souls would prompt Scanga to become the younger artist's closest friend and mentor, and a few years later to be credited as Chihuly's "brother" in studio publications and in conversation. His considerable effect on Chihuly's sensibilities, as well as those of his other students, was invaluable and permanent. Scanga's professional impact did not necessarily change the direction of Chihuly's studio experiments in glass. However, Scanga's astute grasp

Viola Chihuly
Tacoma,
Washington

of overall inventiveness, and his collaborative spirit, assemblage theory, repetitive reinforcement, virtuoso Calabria-based cooking, knowledge of art history and classical music, and an almost religious affection for flea markets and found objects, had to have been a turning point for Chihuly's nonstop, lifelong commitment to collecting. At one point, Harry Anderson, who was on the faculty of Moore College of Art & Design in Philadelphia, drove to Providence to visit Chihuly and Scanga. As a gift, Anderson left Chihuly three 1950s animal-shaped planters (commercial glazed ceramic holders, typically portraying a donkey and cart) that he had procured in a secondhand store the day before. Several months later, when Anderson returned to RISD, he saw that the planter collection miraculously had multiplied into several dozen assorted pieces. Chihuly had been bitten yet again by another species of the collecting bug, reinforcing the realization that congregating objects with a decipherable and consistent form that follows a useful function remained very satisfying, and compared to creating glass works, it was an acceptably inexpensive exercise for him, even including weekly pilgrimages to forage about for unexpected treasures.

Chihuly began to instinctively and quite regularly stockpile volumes of manufactured items from thrift stores and flea markets during graduate school at RISD. The historical South Main Street in Providence, which fronted his studio building, was notorious for its junk and antique shops and dusty clothing stores. Many of the dozens of vintage gabardine shirts that would become a "fashion" trademark for Chihuly at the time were acquired on his way home from the nearby glass shop. Frequently he would make weekend journeys to the Norton flea market just over the state line in Massachusetts with other artist friends like James Carpenter, Seaver Leslie, and me. Needless to say, the prestigious art school environment, with its talented student body, was a mecca for excavating new ideas and imagery and provoked serious discussions about found objects in conjunction with making art. RISD also was known for its illustrious faculty, many of whom were devoted to uncovering the various riches of flea markets, including the aforementioned Italo Scanga, who most often recycled his bargains into spirited assemblage constructions.

It certainly is possible that for Chihuly—by 1970, teaching in the glass program that he had established at RISD the year before—the greatest early, eye-opening influence on his possessing groups of things (and later glass) was carefully examining a landmark exhibition that was curated by Andy Warhol for the RISD Museum, titled *Raid the Icebox 1*. Warhol was invited by then director Daniel Robbins (who later went on to direct the Fogg Museum at Harvard) to rummage through the extensive museum holdings in cold storage and pick out whatever he thought was show worthy. To the surprise of everyone, after five separate visits to the RISD campus, the Pop artist chose such things as old glass cabinets filled with

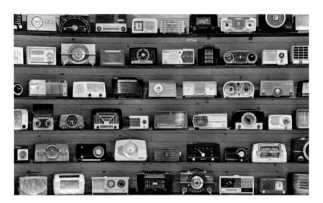

Plastic radios, the Boathouse, Seattle

hundreds of tattered shoes, chairs, parasols, wallpaper, hatboxes, children's clothes, and Native American blankets (something that, years later, Chihuly would collect in huge numbers)—essentially "raiding" a climate-controlled basement tomb of previously undisturbed dusty artifacts, some of which had not been touched since the museum and college were established in 1877.

After resigning his teaching position at RISD and moving back to Seattle in the early 1980s, Chihuly took a much more ambitious approach to collecting, since by then he could afford to vigorously pursue it, by gathering large quantities of things that had an application to daily life and a distinctive visual flavor, whether it was green glass containers, vintage radios (above), 1950s furniture, or dinner plates and cups, each with a unique character, and all of which had to be obtained one by one until the objects, adaptively reused, became decoratively effective and practical in

their new home environment. As did Warhol, Chihuly delighted in unearthing fresh categories that interested him, which he perpetually adds to even today. In our investigation and documentation of Chihuly's original passion and obsession, we gain a deeper insight and appreciation for his foresight, discipline, courage, determination, and cleverness as a collector and artist—all exceptional, invaluable aspects of his undeniable genius.

It needs to be noted that, first, the majority of Chihuly's collections are based on the individual and imaginative designs that are frequently handmade into intriguing and ornamental utilitarian objects. And second, often the illustrative thread that binds these objects is fundamentally beautiful, whether it's an assortment of matchbook covers or carnival figures drawn in chalk. From his early college days, Chihuly always has maintained a voracious appetite for acquiring extraordinary items that have a related mutual theme. Another component of the artist's penchant for collecting was his time as an undergraduate student of interior design at the University of Washington in Seattle. The concept of studying interior spaces and places, and, in Chihuly's case, conceptualizing and drawing out the actual rooms, triggered his predisposition to collect and became a motivator for him to fill up an empty space with collections of things and works of art, which later he became a master at coordinating and arranging.

Collecting has been such an intricate and significant part of Dale Chihuly's life that it certainly

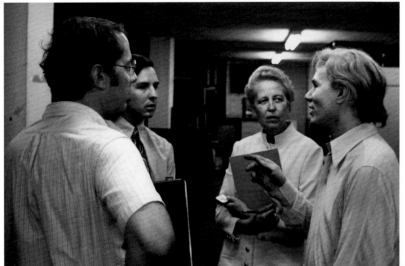

Left to right: David Bourdon, Fred Hughes, and Dominique de Menil talk with Andy Warhol, curator of the exhibition *Raid the Icebox 1*, Museum of Art, Rhode Island School of Design, April 23–June 30, 1970. Below: One of the installations

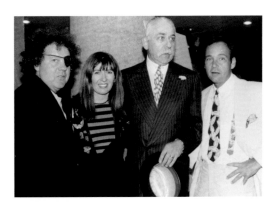

Left to right: Chihuly, Nicole Miller, Richard Merkin, and Bruce Helander, 1991

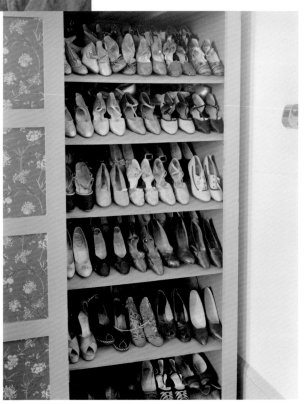

is exciting to view the first comprehensive hardcover record of his compilations, including insightful, specialized commentary on the ongoing achievement of harvesting and elevating commonplace but disparate groups of objects with odd but welcoming facades. Chihuly has enveloped himself in a truly rare atmosphere that has no equal. Like his glass combinations and famous installations that have become ultimate sculptural statements, his multitude of fascinating items remains thought-provoking and impressive in the continuing balancing act between sustaining his illustrious career and accumulating the things that he loves and preserves.

It is important to examine early evidence of other positive and persuasive influences that were supportive elements in sharpening Chihuly's vision and, in retrospect, surely helped ignite his curiosity for collecting and the natural instincts that he both inherited and enthusiastically developed, which also were recognized and encouraged to progress by the people with whom he associated. It can't be emphasized enough that the single greatest effect on him came from his dear lifelong friend, the eminent neo-Dadaist sculptor Italo Scanga; their close bond lasted thirty-three years, until Scanga's untimely death in 2001. Like many prominent artists who enjoy surrounding themselves with often astonishing things, Chihuly has been captivated since childhood by objects and their placement, and he continued to collect as his success expanded in all directions. His engaging with multiple items that have a kindred

spirit, and his amplifying the aesthetic merits of objects in repetition with a common denominator, is the signature attribute of his collections.

RISD'S eclectic environment likely was one of the most valuable experiences toward shaping and guiding the direction of Chihuly's art and collecting, as he constantly was around the college's creative, inspired atmosphere. Among the colorful faculty members at the school was Richard Merkin, a painter who at the time was the most committed collector of vintage items at RISD; he also was a writer on sartorial flair for *Esquire* and *Vanity Fair*, setting a profound example in singular style for young, adventuresome students on campus. Merkin took his own collecting seriously, operating meticulously and methodically, and descriptions of his new discoveries were an anticipated part of many conversations in the RISD basement snack bar during the midafternoon studio breaks for faculty and students. Regulars at this watering hole included teacher and artist Hardu Keck; painting students Seaver Leslie, Kenn Speiser, and Victoria Wulff; David Fowler, a portrait model and intellectual, funny man; and me, as well as, occasionally, the soft-spoken architecture and sculpture student James Carpenter, who later became Chihuly's studio mate, assistant, and brilliant collaborator. From the outside, it looked like quite a quirky crew taking five from a movie set: Scanga in overalls; Merkin in impeccable threads protected by a white apron and topped off with a vintage baseball cap; Chihuly in one of his popular 1950s bowling

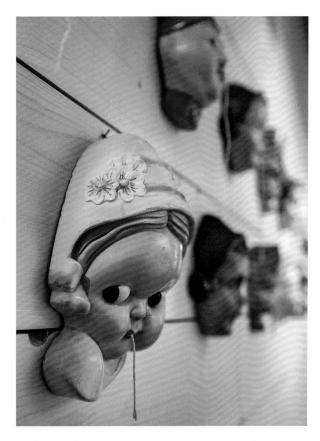

String holders, the Boathouse, Seattle. Opposite:
Vintage appliances in Dale's studio, Seattle (left),
and the Boathouse, Seattle (right)

shirts; and Fowler in a clownish model's costume (put together by Professor Merkin). Among other things, Merkin sometimes would pull out of his tailor-made jacket's inside pockets a selection of small, offset catalogs for advertising and tobacco tins, Tijuana Bibles, Little Big Books, vintage baseball cards (especially early Negro League stars), or a variety of other collectible items that none of us had ever seen or even heard of before. These regular "show-and-tell" moments, kind of de facto Cedar Bar opinionated discussions about art and life, would have an enduring motivational impact on all of us in terms of the evaluation of style and the joys of collecting. It should be noted that at the same time, there were a number of students on the RISD campus who shared Chihuly's ambition, energy, and vision, and would later become well known, including Nicole Miller, Mary Boone, Jenny Holzer, David Byrne, Martin Mull, and Roni Horn.

As an art critic and curator, as well as an artist, it seems to me that it is nearly impossible to put Dale Chihuly in some kind of collecting categorical context, simply because of the sheer volume and complexity of his congregation of objects. Trying to make a convincing argument about other comparative artists is utter folly, as I know of only one other living artist who may be in a similar ballpark, and that is Hunt Slonem, whose 35,000-square-foot studio in Brooklyn is overflowing with his spectacular collections of vintage items, from neo-Gothic chairs and glass decanters to antique frames and candelabra. In fact, as I mentioned earlier, only two artists, Picasso and Warhol, had the same foresight and enthusiasm for collecting—actually, hoarding—that one can associate with Chihuly, and as far as objects go, he has them both beat. Most artists are fortunate to possess the creative gene that opens your eyes and sweetens your visual appetite to appreciate virtually everything, particularly collectibles, and this seems to be

especially true of certain types who value the seeking out of discoveries equal to actually creating works of art. On the first page of Chihuly's delightful pocket catalog published for the Collections Café (located at *Chihuly Garden and Glass*, next to the Space Needle in Seattle), he is quoted with one simple sentence that best describes the joy and satisfaction he receives from building up collections: "I love to find the beauty in everyday objects." Not surprisingly, Chihuly's studio work is irrefutably about beauty, craftsmanship, and contour, as well as the aesthetics of repetition and organization (cultivation) of a collection of handblown objects that are all different, but are strongly connected by a universal trait. Traditionally, early forms of glass often were decorative, but they also served as vessels for drinking and holding water; many of these are now cherished collectible items.

For the functional side of Chihuly's collections, the artist commemorates the grand innovation and resourcefulness of humankind by selecting types of objects that have a direct and strong appeal to his desire for items that have become hard to find and eccentric, but also are useful. For example, the dozens of vintage shaving brushes (p. 8), made from bone and plastic in every conceivable hue and form, reveal a special homage to man's expertise in style, where striking and often simple designs over the years became classic. It should be pointed out that a great deal of these practical categories are filled with things that could be seen in almost every home at one time or another. About string holders (p. 18), one of my favorites, Chihuly has observed: "Before World War II, everyone wrapped packages with string—nothing was wasted. You needed a way to dispense the string, so you would hang these on the walls of your kitchen." Now, these wonderful chalk shapes with strings attached and lined up together present a dynamic design statement that is inherently

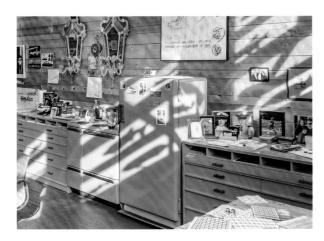

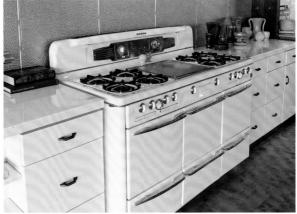

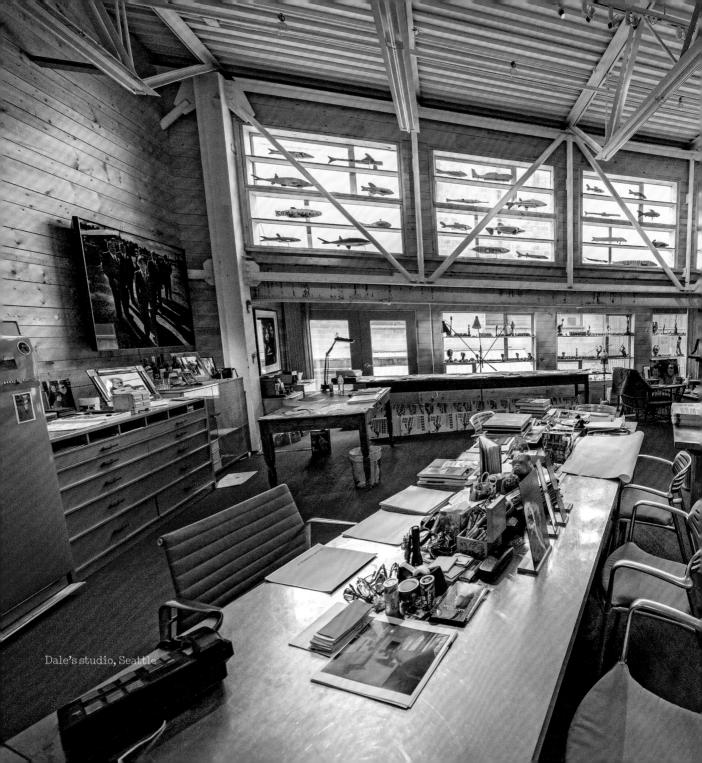

Dale's studio, Seattle

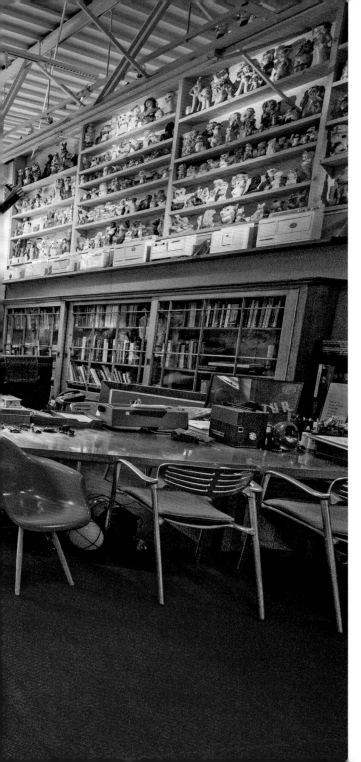

humorous, while each one's cheerful personality is amplified considerably. It's not surprising that Chihuly has a special fondness for kitchen environments, as throughout his life, wherever he settled, he always was interested in outfitting his home with appliances like vintage stoves and a 1950s refrigerator (p. 19), as well as Art Deco kitchen furniture, Fiestaware dishes, bottle openers, juicers, and plastic kitchen clocks and radios, which frequently would be surrounded by antique thematic wallpaper and linoleum. During his first year of college, Chihuly remodeled his mother's recreation room, and the experience was so gratifying that he decided to study interior design; a few years later, he was employed by John Graham, an architectural firm in Seattle. Wherever Chihuly decided to establish his nest, whether it was his thrift store–furnished digs deep in the forests of Stanwood, Washington, during the early days of the legendary Pilchuck Glass School, or the masterstroke of finding a historic boat facility on Lake Union in Seattle, he continued to surround himself with wonderfully charming, handpicked objects and appliances, including the vintage flooring and wallpaper he would have installed. Each environment was noteworthy because of the vitality, integrity, and thoughtful playfulness that infused every room.

In addition to his incredible renovation of the Boathouse into a home and glassblowing studio second to none in the world, Chihuly acquired a large building in the Ballard neighborhood of Seattle. This workplace, where his offices are located, also serves

as a mock-up area for planning future museum shows. Chihuly's studio (pp. 20–21) is completely saturated with and encircled by the accumulated treasures he loves to live with every day. From his desk, he can enjoy the mind-boggling display of more than 100 hardcover books on Vincent van Gogh, who was the subject of one of Chihuly's college term papers; this private installation of so many published books on one artist becomes a bona fide work of art itself, like many of his other categories of collecting. Above these immense shelves is an assortment of children's tin stoves, and even higher sits his massive collection of vibrant chalkware figurines, many dating back more than a century. These intriguing animals and people made out of painted plaster of Paris primarily were used as prizes at carnivals. The "carnies" would carry the molds with them from town to town, and when they ran out of trinkets, they would simply mix up some plaster and cast more inventory. Although the sighting of just one of these curious snippets of our past often produces a smile, seeing Chihuly's entire congregation all at once is an exhilarating encounter that has not been duplicated elsewhere. Another wall showcases a "school" of handmade fish decoys, which have the gentle, honest spirit of original folk art, whose attraction for Chihuly very likely was connected to his experiences fishing for salmon in his youth. Virtual armies of vintage painted lead toy soldiers in marching order are stationed on long window shelves, each with its own gorgeous patina, no doubt worn down over the past 100 years

or more during children's playtime war games. A close-up view shows a single cast sailor boy (p. 23), standing at attention with the rest of his outfit, who is representative of the significant appeal of Chihuly's choices: in this case, a distinctive patina of light blue next to the aging white trim of the sailor's scarf and cap; handsome skin tones that are adjacent to a brushed-on green base; a tiny touch of red for his lips and a black dash for an eye—the sailor could qualify as a possible maquette for one of artist Jeff Koons's towering sculptures. This little seaman alone packs a mighty punch for only a four-inch-high deckhand, and these beguiling groupings of the well-dressed military inspected as a unit demonstrate superior aesthetic qualities.

Since his youth, Chihuly always has had a keen interest in automotive imagery, which is reflected in his extensive collections of related items, such as toy trailers, small toy cars, and tin racing vehicles. In 1957, he inherited an Austin-Healey 100 from his brother, George, and in 1986, with the help of vintage car expert (and art dealer) Paul Fisher, he purchased the 1956 Aston Martin DB2/4 convertible that Tippi Hedren drove in the Hitchcock movie classic *The Birds*. Chihuly's ambition at the time was to collect one of each model of Aston Martin from postwar to present and create the "Lake Union Aston Martin Museum." Along the way, he owned dozens of rare and exotic autos, and his everyday motoring choices included high-powered pickup trucks custom painted in unusual colors, including pink and seafoam green.

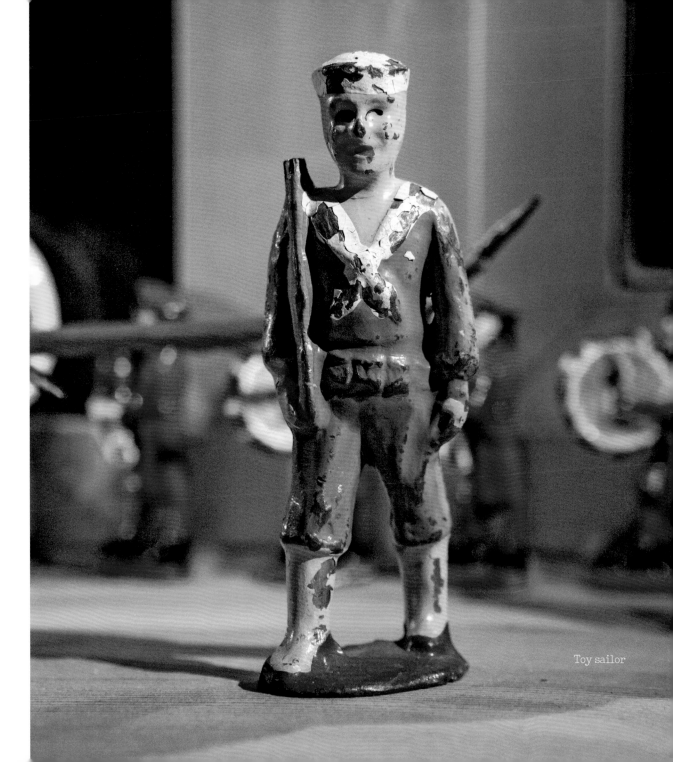

Toy sailor

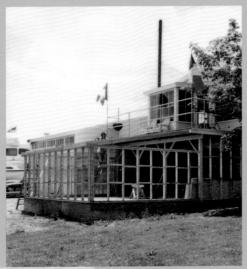

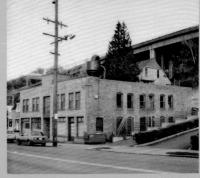

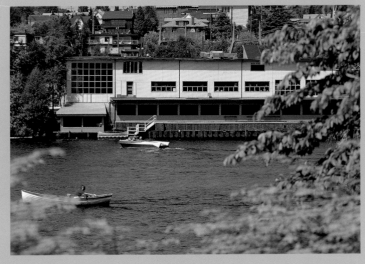

Clockwise from top left: The Boathouse, Pawtuxet Cove, Rhode Island; Pilchuck Cabin, Stanwood, Washington; the Boathouse, Seattle; Buffalo Shoe Company Building, Seattle

The range of Chihuly's collections is astounding, including pocketknives, inkwells, alarm clocks, posters, Native American blankets and baskets (these were the incentives for two of his most famous series: the *Navajo Blanket Cylinders* and the *Baskets*), cast-iron dogs, and even bouquet-shaped cast-iron doorstops, not to mention Lucite purses, wristwatches, and Christmas ornaments—all selected by a master hunter-gatherer with the same exceptional eye and enthusiasm as found in Andy Warhol. Is there a rhyme or reason to these eccentric and seemingly haphazard groupings, with their variety and bewildering scale? The answer probably is that while there may be some childhood event that had piqued his initial interest in stockpiling certain things like accordions, doll furniture, ceramic dogs, tin toys, toy cars, and house trailers, the bottom line for Dale Chihuly is that there is a definite pattern to his manner of amassing objects that fascinate him: to "develop" a specific bundle of items or compile existing collections, the acquisition must retain an ageless, dramatic, and inherently handsome profile.

As the following pages illustrate, like Dale Chihuly himself, who arguably is one of the most intriguing, multitalented artists living on the planet, it should be no surprise that another extension of his creativity and boundless visual energy is the gratification he receives from his unceasing search for items that stimulate him as a modern-day perpetual prospector; a curator, librarian, architect, and historian, all in one; and a discriminating connoisseur of flea

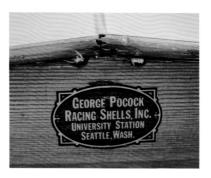

Pocock racing shell (detail) The Boathouse, Seattle

markets and secondhand stores (often assisted by "pickers")—always looking for that magical moment of discovery.

Chihuly always has had an attraction to water and the accompanying coastlines. When he was a boy, his mother encouraged him to collect beach glass along the shore near their home in Tacoma. He has lived most of his life near the water, from his quaint little 1860 house in the College Hill section of Providence near Narragansett Bay (a home that I also formerly occupied, before Chihuly lived there), to the little Boathouse on Pawtuxet Cove in Rhode Island ("the Ocean State"), to weekend escapes to nearby Block Island (off Rhode Island), to his residences and studios in Washington State. Consequently, the water theme has been there throughout his life, eventually appearing as seaforms in some of his most renowned glass assemblages.

When Chihuly moved to Seattle in 1985, he purchased the Buffalo Shoe Company Building, just east of Lake Union, the first of several structures that he bought, which also included the Nisqually Power

Substation (which was an actual power station) in Tacoma. In 1990, he secured the Pocock Building, situated on Lake Union, and called it the Boathouse, because it was the former home of Pocock Racing Shells (p. 25), founded in 1911. The building initially was where elongated crew boats were fabricated, one of which was specially built for the 1936 Olympic Games in Berlin and mentioned in the book *The Boys in the Boat*, describing the crew's victory for the gold medal over Nazi Germany. Now, this meandering renovated structure is an authentic architectural gem, stationed on the water's edge with a view of constantly passing boats and crews rowing by to this day. The Boathouse became a natural environment for many of Chihuly's collections to be properly and idiosyncratically staged: the former interior designer with a special flair for putting objects together was able to personally lay out every room with complementary preferred collections. His kitchen was built around still-working 1950s appliances, painted in his favorite shade of light yellow and accompanied by vintage pantry devices along with a wonderful assortment of tableware and accessories. The Northwest Room displays both Native American baskets and Chihuly's own early glass *Baskets* on multiple shelves, which are bordered by anything else that seems suitable, including a classic Indian motorcycle, along with a host of dog-shaped doorstops and the artist's wealth of French club chairs. The formal dining room—the Evelyn Room (p. 27)—houses an eighty-five-foot-long table, made from one continuous piece of Douglas

fir, and 100 matching Eames chairs. And Chihuly's indoor swimming pool has an outstanding selection of his glass installed both beneath and above it. Even though the Boathouse is judiciously filled to the brim with a curator's sensibility—not jammed together—and each floor, including bathrooms, seems to reflect a great lasting marriage of art and purpose, the items there actually are less than 10 percent of what Chihuly already had acquired and stored, which again reminds me of Warhol's extreme sensitivity and discerning taste for outfitting his Upper East Side home with marvelous things, as well as having a much larger reserve of possessions at various storage locations.

People have accumulated collections of things for thousands of years, and Dale Chihuly clearly has embraced this honored ritual with enthusiasm, a remarkable and discriminating dynamism, and a stunning consistency. If we look to our past for inspiration and for comparisons to this artist's splendid obsession and ongoing commitment to his mission, we uncover an ancient, avid tradition that seems to be embedded in our collective genetic material and is passed on like a runner's baton to the next person who wants the challenge in a contest requiring endurance, resourcefulness, and determination. From the Chinese Terracotta Army statues (c. 220 BC) to the collection of books from around the world by the Egyptian Ptolemaic dynasty; to the "cabinets of curiosities" of the mid-sixteenth century and after, developed by scholars for posterity and the public;

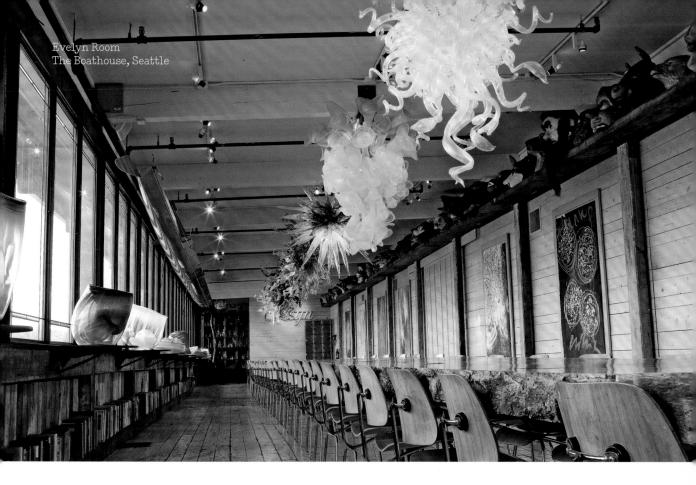

to ceramic pots and arrowheads, and later, coins and stamps and everything else imaginable, license plates and lunch boxes, pet rocks and moon rocks—the practice of collecting has evolved into an art form by itself. Dale Chihuly proudly and wholeheartedly joins this distinguished fraternity of gatherers by splitting his concentration between his phenomenal work as an artist and that of the consummate collector, who consistently seeks out the unusual and the hard to find, then professionally organizes and catalogs his discoveries, and finally displays his acquisitions in a jaw-dropping curatorial style. These often curious items that he chooses to love and with which to live, assimilating their inherent beauty, ingenuity, creativity, and craftsmanship, their individuality and invention and recognizable strength of a thread, all reflect the balanced values and polished vision of the artist-collector and the satisfying, challenging way of life that he has chosen.

FEATURED COLLECTIONS

Accordions . 70, 140–45
Alarm clocks . 48
Artwork (by Edward S. Curtis) 160–63
Artwork (by Stanislav Libenský and
 Jaroslava Brychtová) 100–101
Artwork (by Italo Scanga) 154–55
Artwork (by Paul Stankard)108–9
Baskets (Native American) 164–67
Birdhouses and bird hotels90–93
Blankets (Native American trade)
 .96–97, 169–77
Bookends (Cast-iron) 34
Books (Art) 114–15, 153–55
Books (Children's) 156–59
Bottle openers .56–57
Cameras (Mid-century)50, 148
Canoes (Willits Brothers)96–99
Carnival items (Chalkware)32, 73, 110–11
Carnival items (Masks) 136–38
Chairs . 116–21, 154
Chairs (African bead) 146–47
Chairs (French club) 162–63
Christmas ornaments (Vintage) 42
Coffee carafes (Bauer) 68
Dance-hall star lights 130, 132–33
Dogs (Ceramic) . 35
Dollhouse furniture . 49
Doorstops (Cast-iron bouquets, dogs)
 . 36, 37, 69, 170

Fish decoys (Wooden)60, 71
Fishing plugs . 58
Fly-fishing reels and rods62–63
Glass (Figurines) .106–7
Glass (Roman) .104–5
Glassblowing molds 126–27
Glass color rods . 128–29
Inkwells (Silvered) . 44
Juicers (Glass) . 66
Matchbooks . 139
Models (Boats) . 72
Necklaces (African bead) 65
Pocketknives .40–41
Postcards (Vintage)76–85
Purses (Lucite) . 151
Radios (Mid-century) 149
Radios (Transistor) . 52
Record albums . 150–51
Shaving brushes . 53
Slides (of trailers)86–89
Sombreros (Mexican silver) 43
Stamps . 122–23
Statues (of Buddha) 134–35
String holders54, 130, 132–33
Toys (Cars) . 64
Toys (Soldiers) . 38
Toys (Stoves) . 110–13
Toys (Tin) . 59
Toys (Trailers) .46–47

For a current list of Dale Chihuly's collections, please see pages 180–81.

I'M ALWAYS LOOKING.

Dale Chihuly with camera, 1994

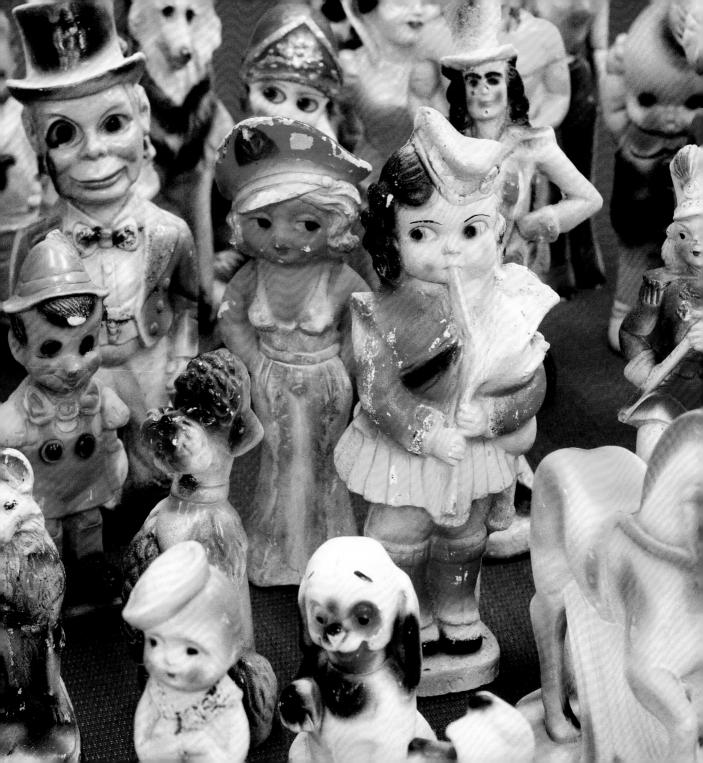

Chalkware dates back more than a hundred years. Until 1960, carnivals would give them out as prizes. They carried molds with them, and when they ran out of prizes, they would buy some plaster and cast more prizes.

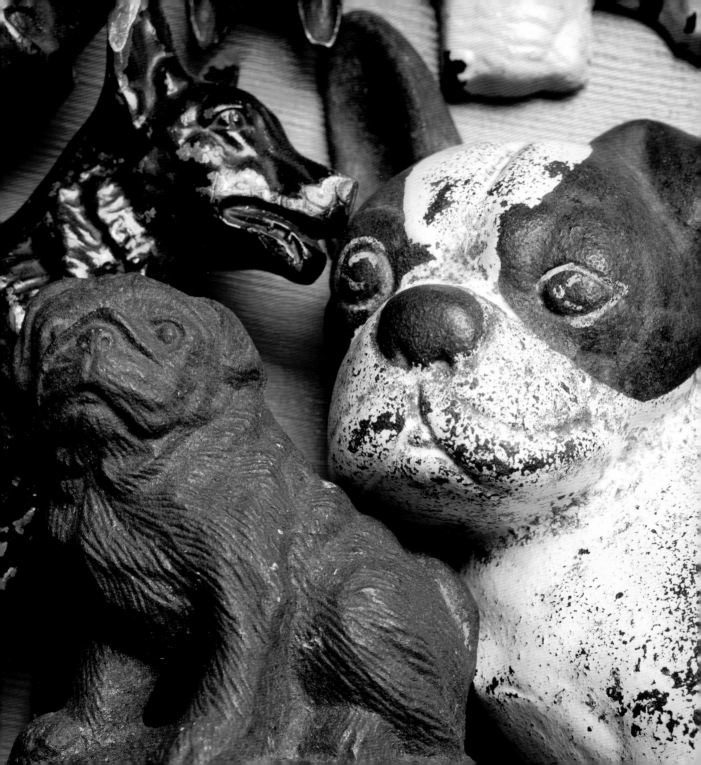

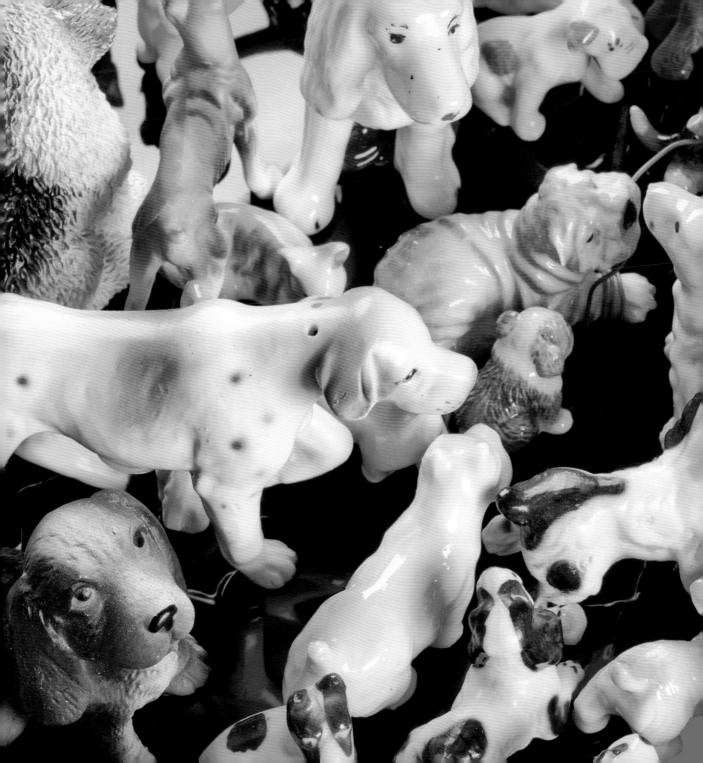

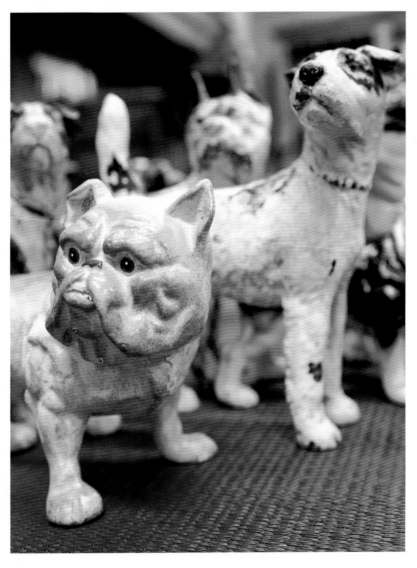

I think these cast-iron dogs are about a hundred years old. They were used as doorstops, which is why they have such a lovely patina.

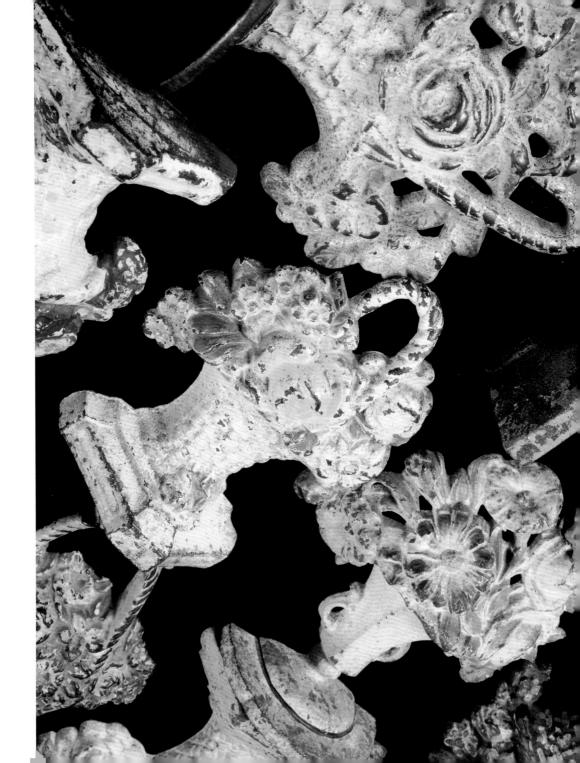

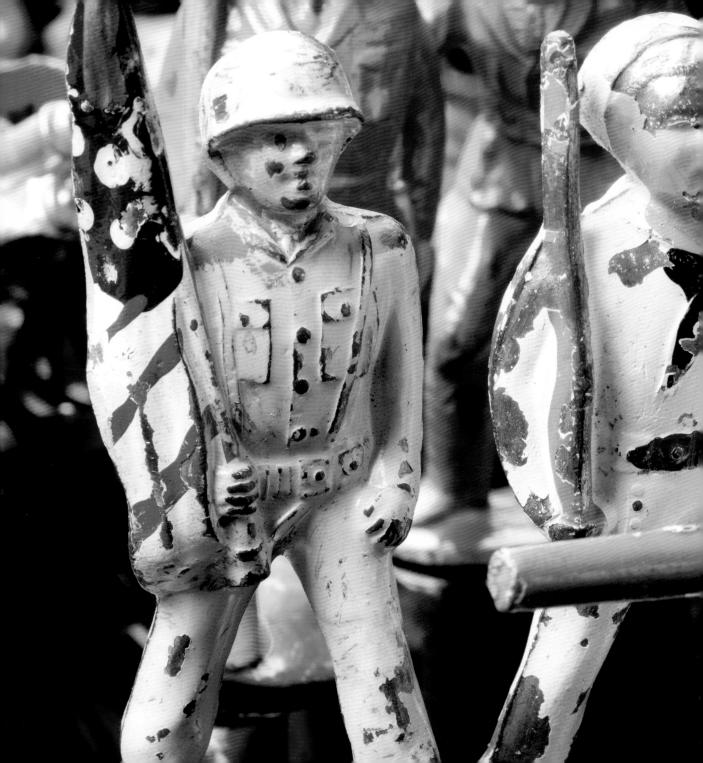

One of my first collections was leaded toy soldiers in the 1940s. A company called Barclay supplied most of them. I'm as excited about them today as I was seventy years ago.

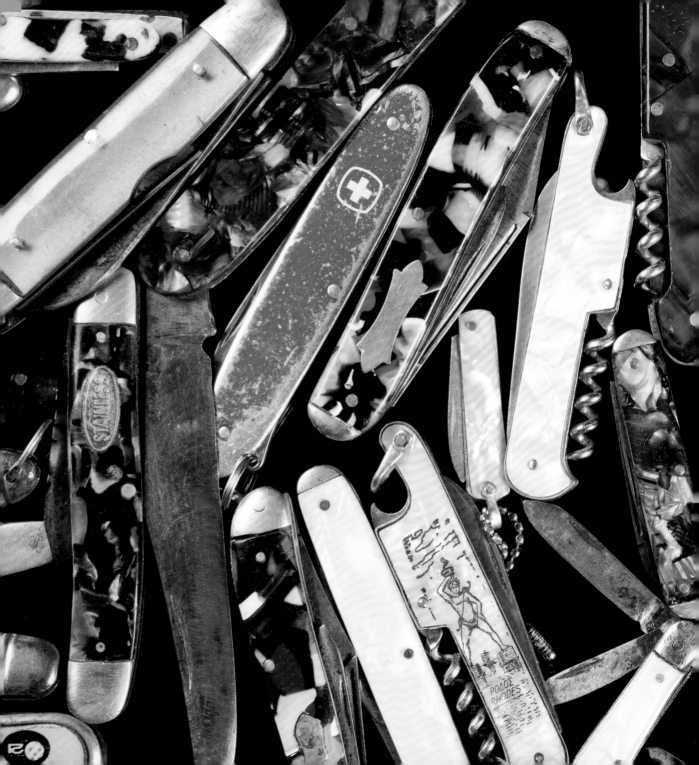

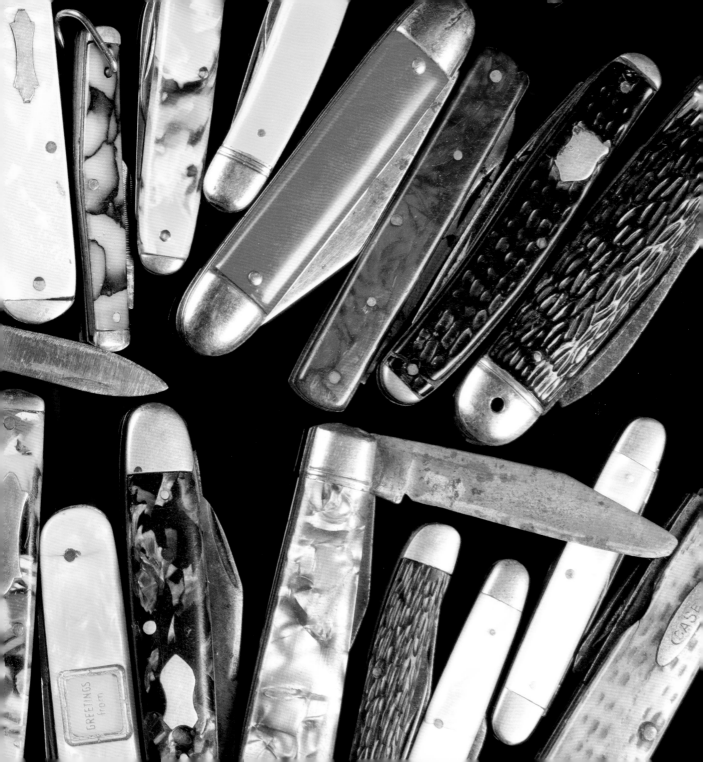

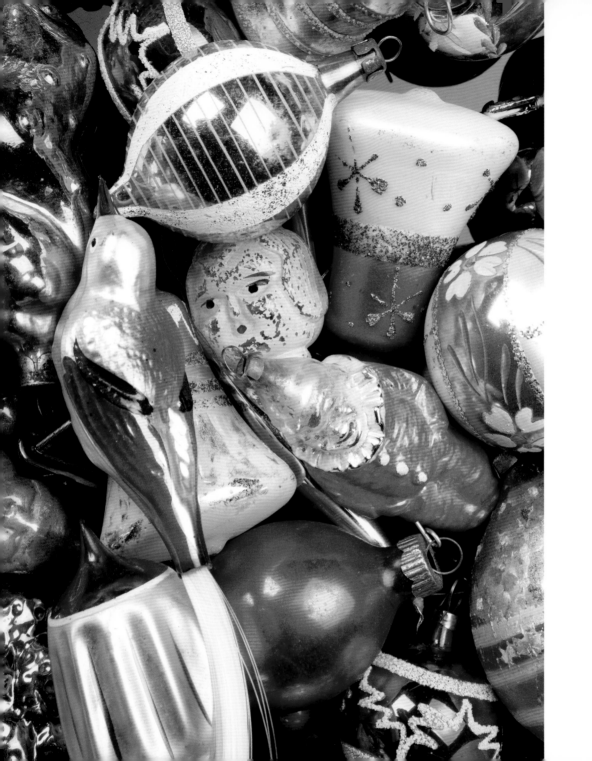

I bought these in a little antique shop in Ojai, California, not really knowing what they were. I thought they must be ashtrays.

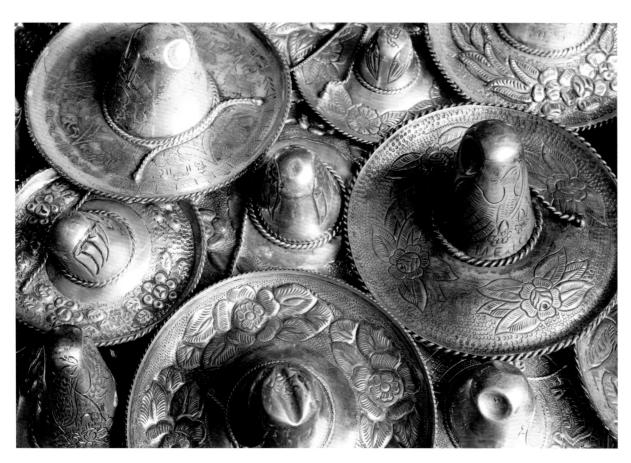

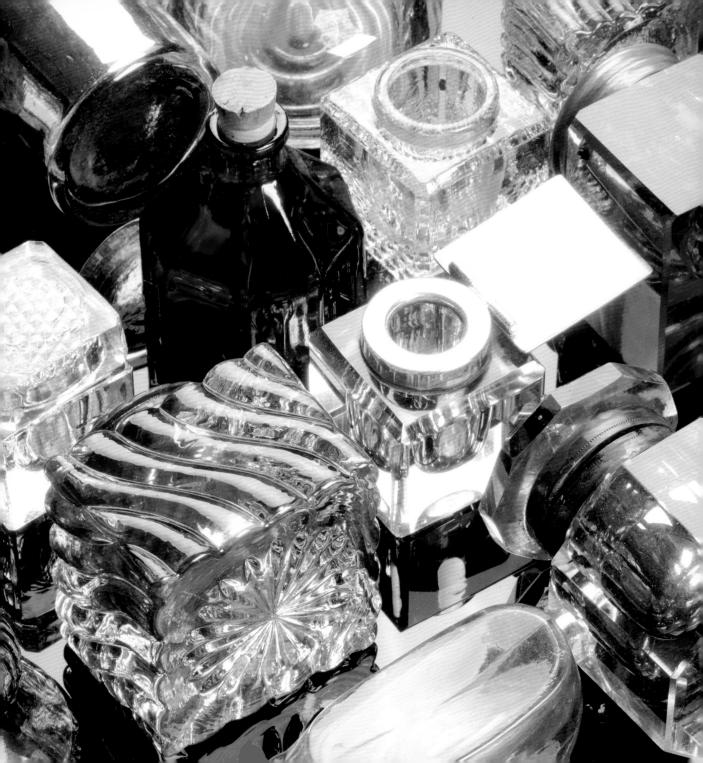

Inkwells date back a thousand years or more. This collection is mostly from the nineteenth and twentieth centuries. They have great variety in size and color, and I have taken the liberty of silvering some of them.

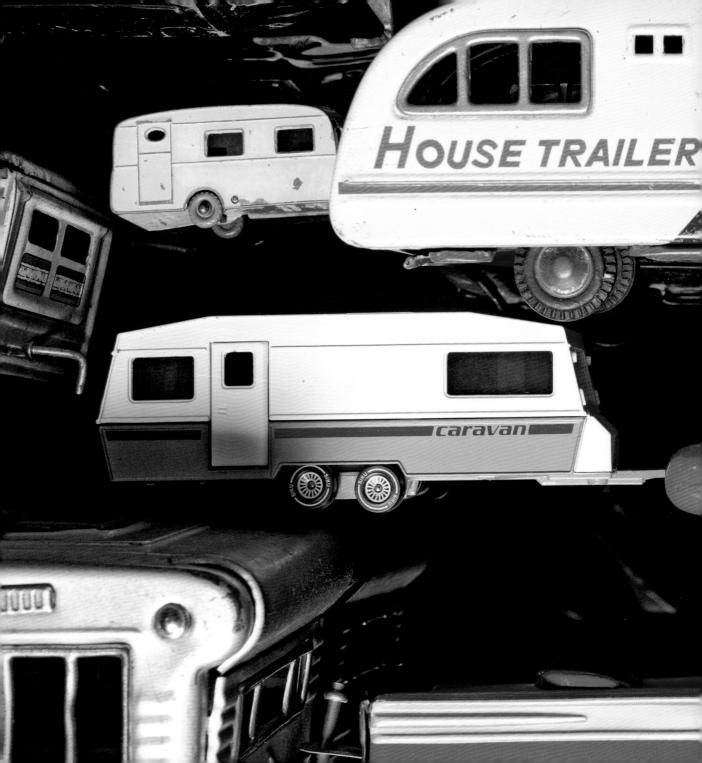

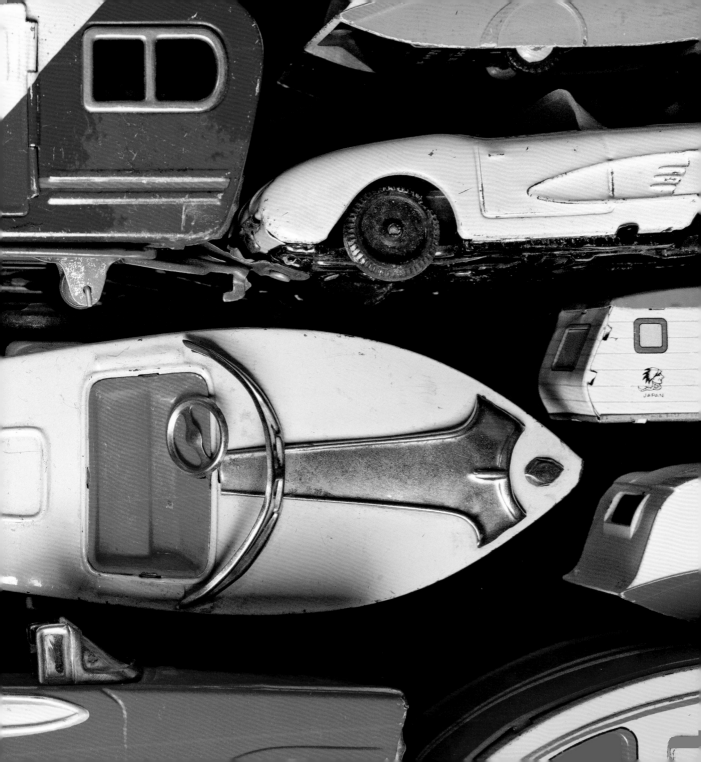

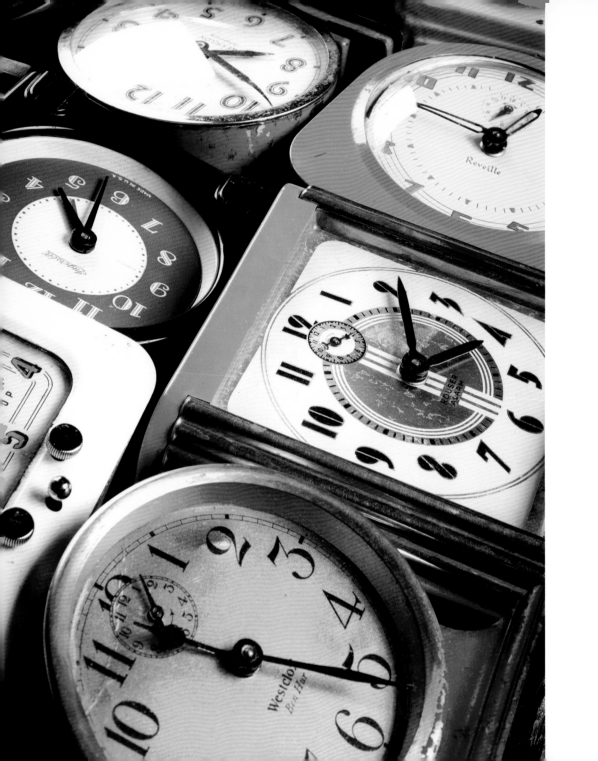

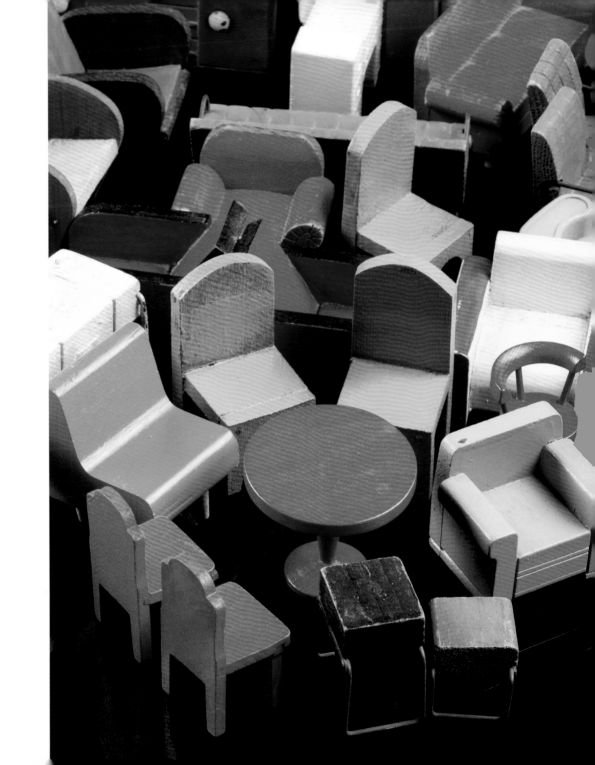

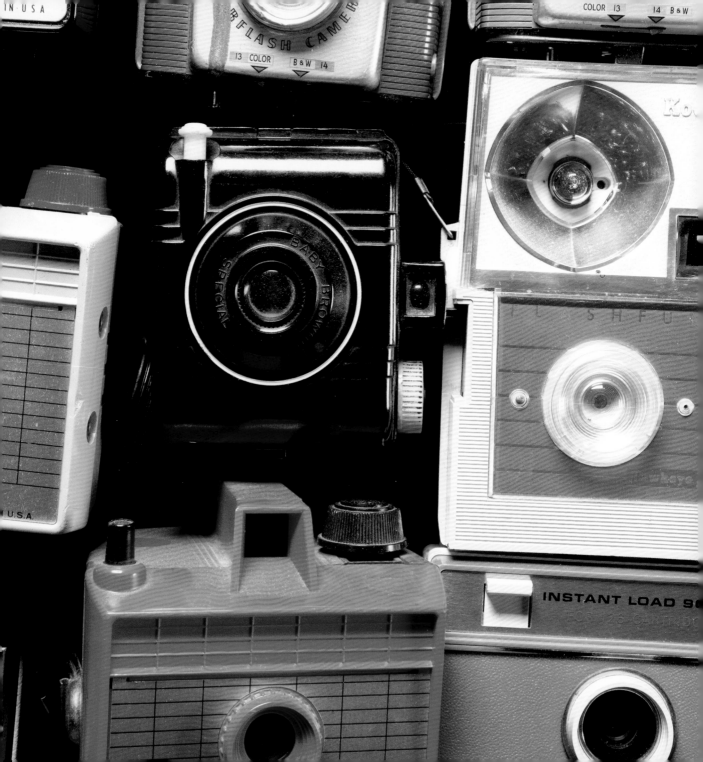

There is something about a bunch of 1950s cameras that makes you smile.

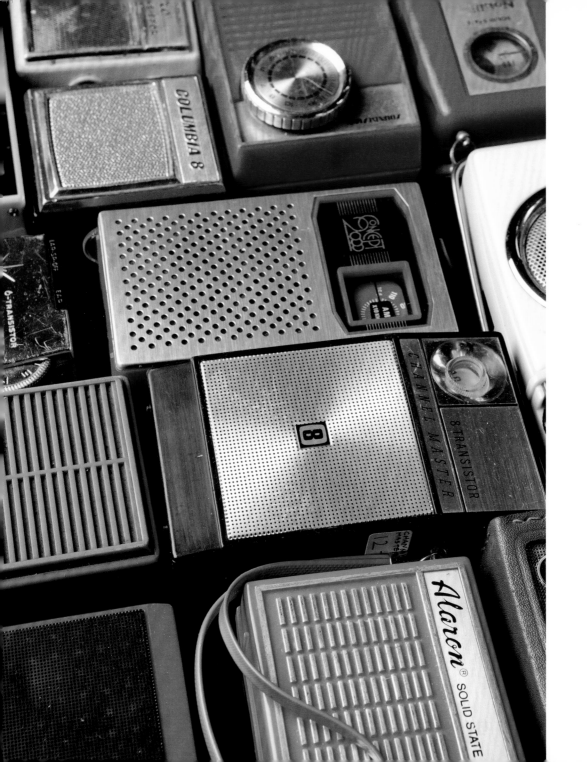

Transistor radios were the iPods of the 1950s. It seemed as if everybody walked with a transistor radio up to the ear.

One shaving brush is not so interesting, but when you put a bunch of them together, they make quite a statement.

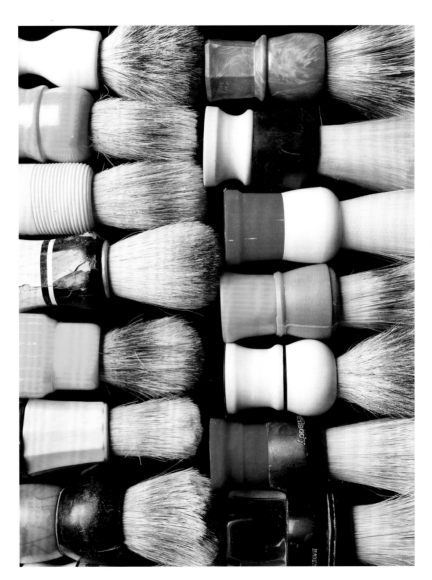

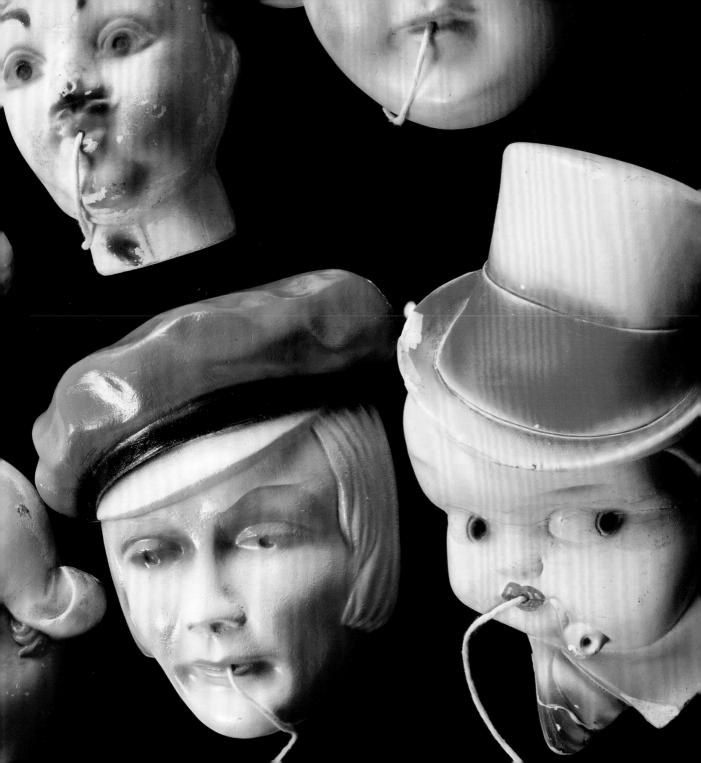

Before World War II, everyone wrapped packages with string; nothing was ever wasted. Since one needed a way to dispense the string, you would hang these on the kitchen walls.

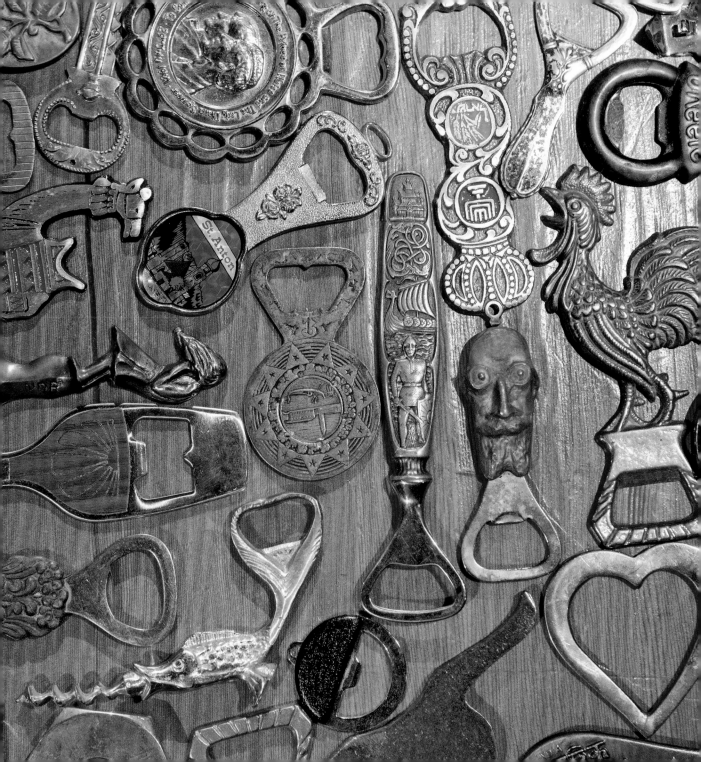

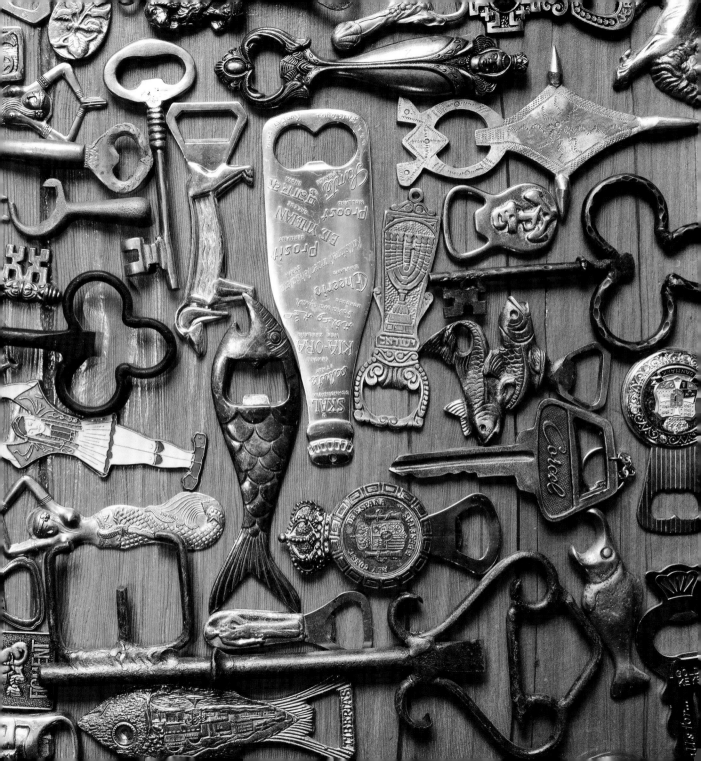

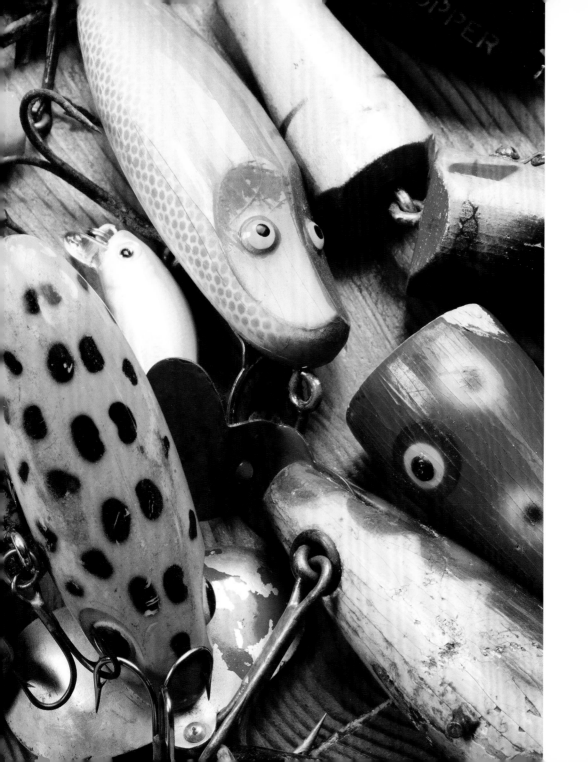

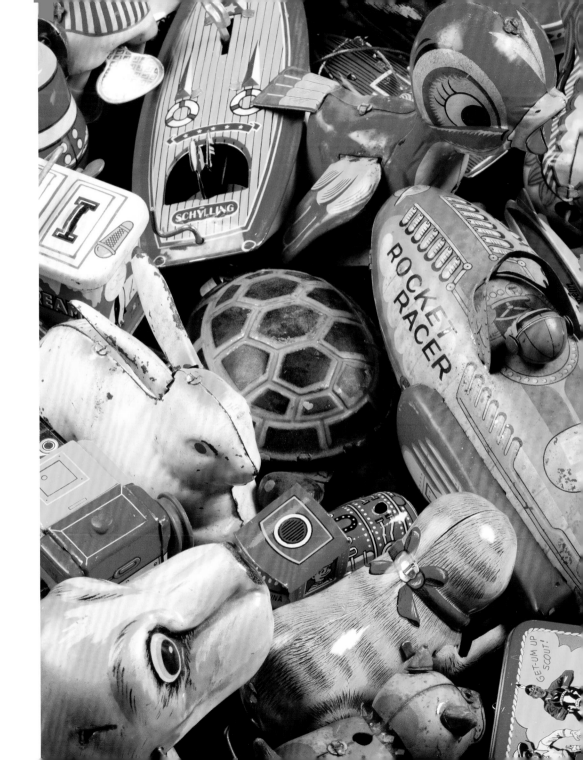

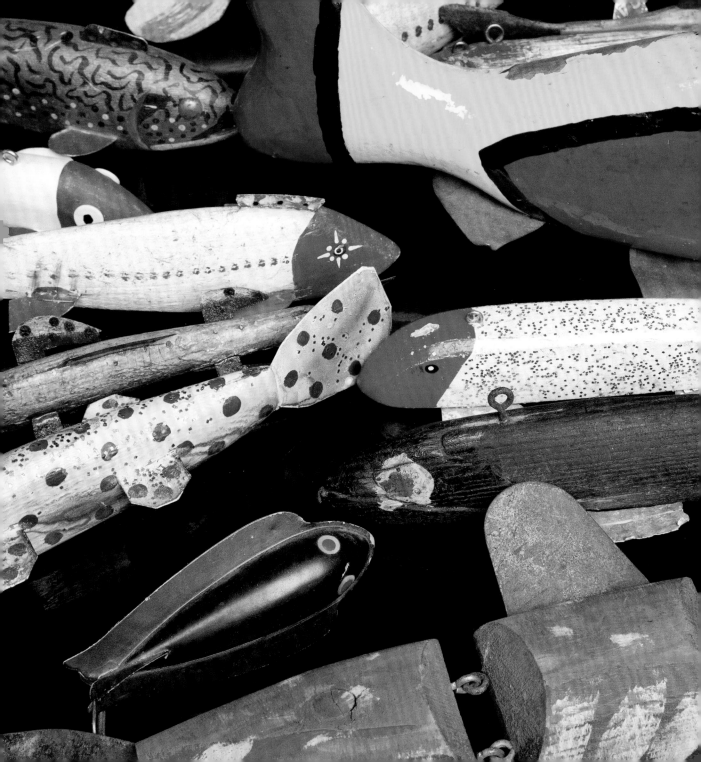

Carved out of wood and submerged underwater to attract fish, these are still made in the Great Lakes area, where they are commonly used for ice fishing.

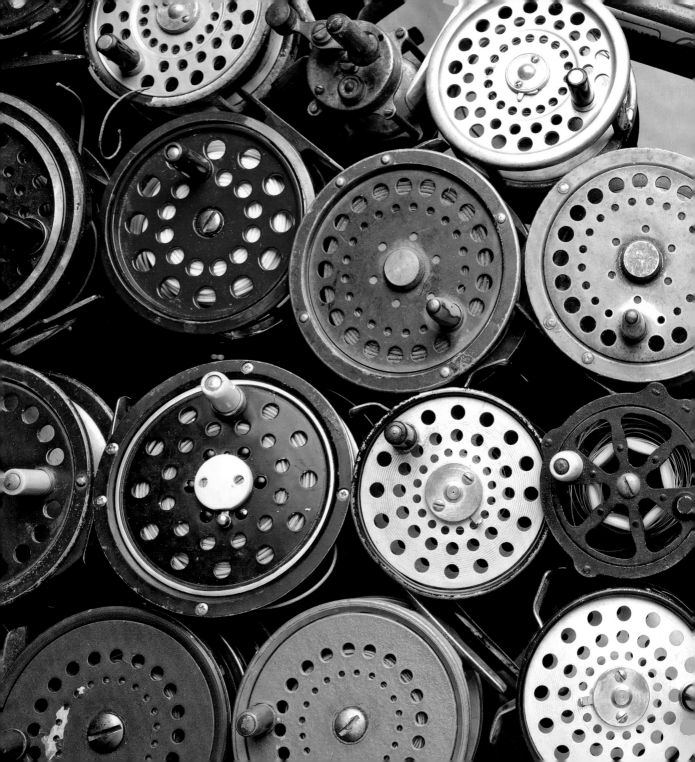

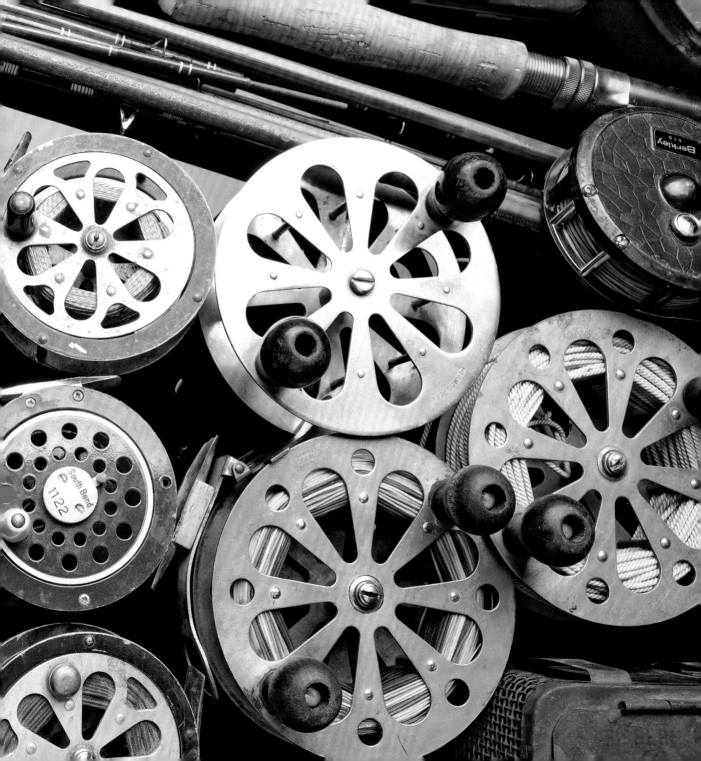

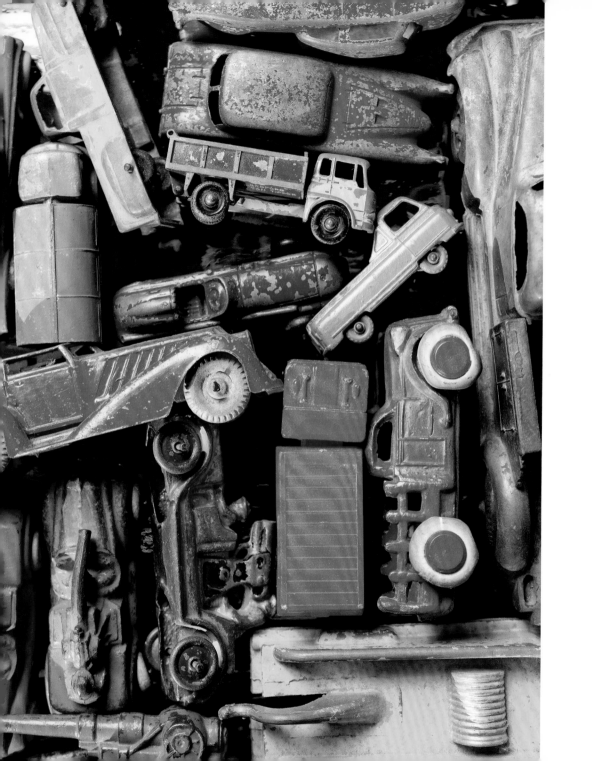

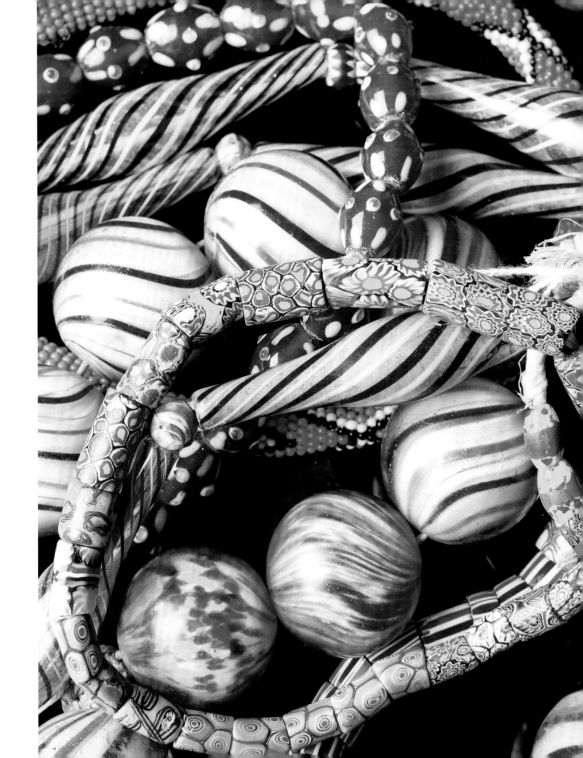

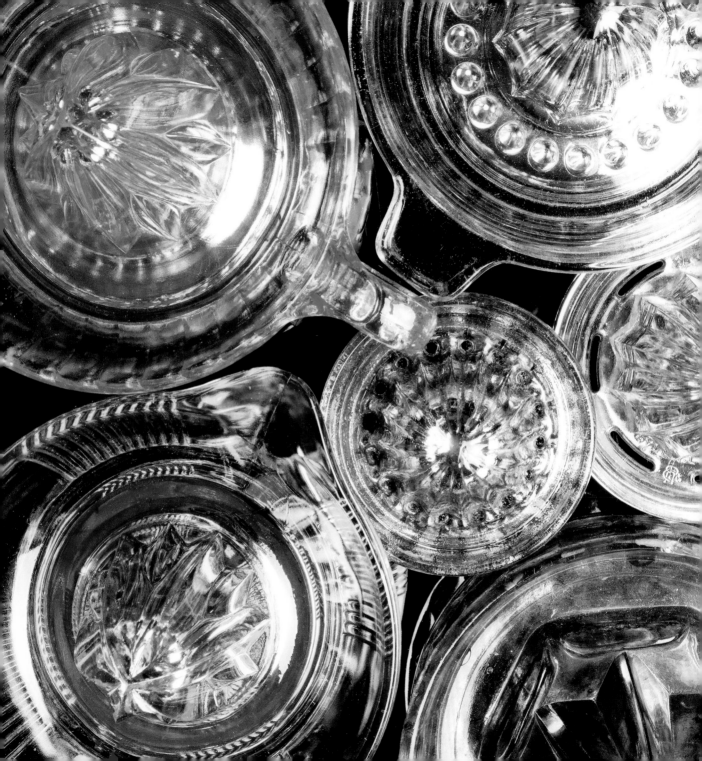

Hundreds of companies made reamers or juicers in the twentieth century. The glass ones are my favorite, especially when they are silvered on the bottom. All the lines and patterns become accentuated and brilliant.

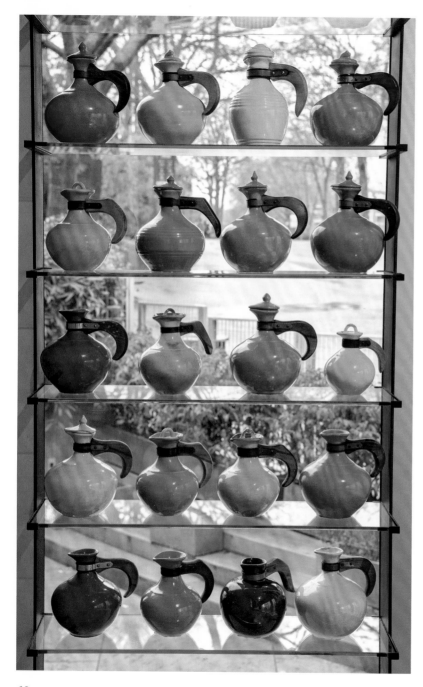

Collections Café
Chihuly Garden and Glass,
Seattle

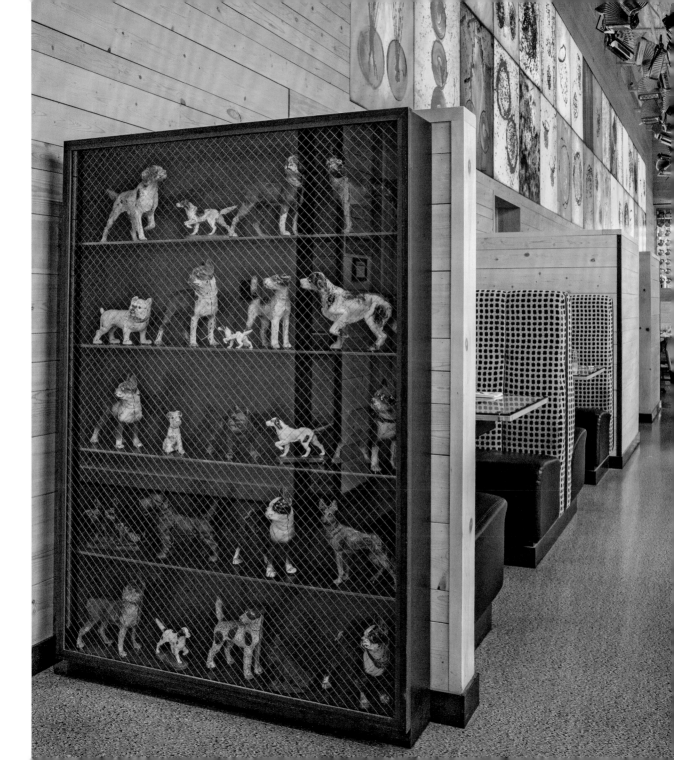

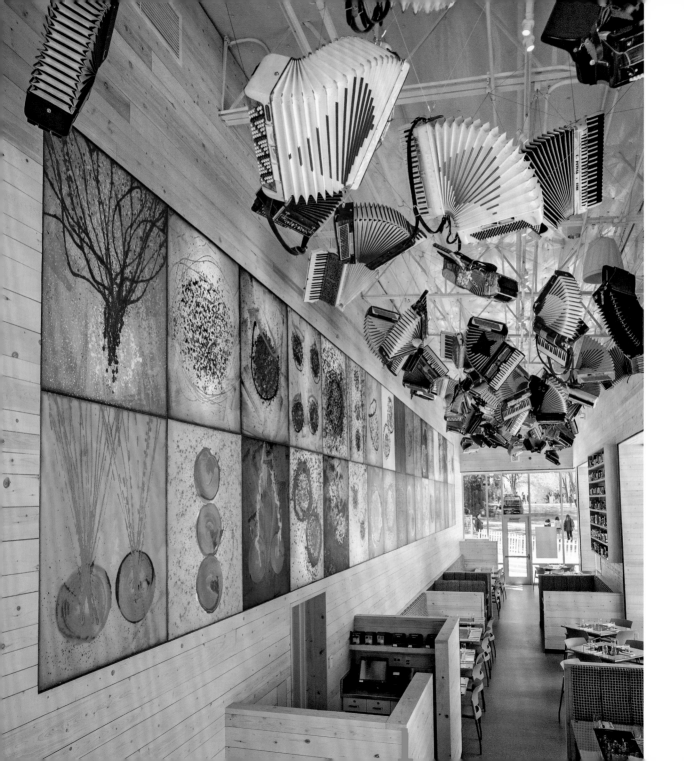

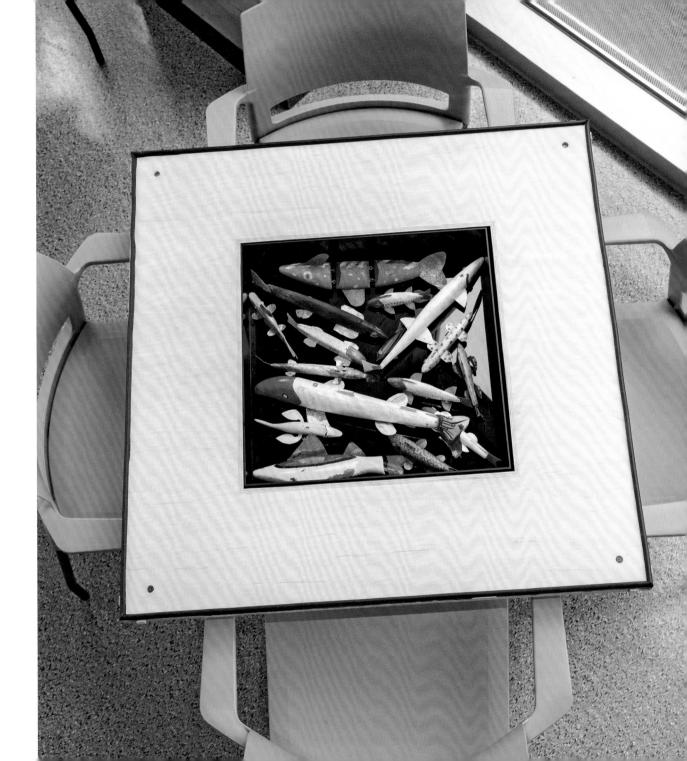

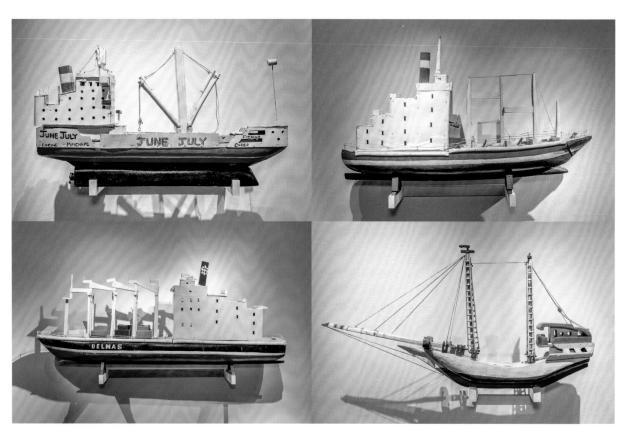

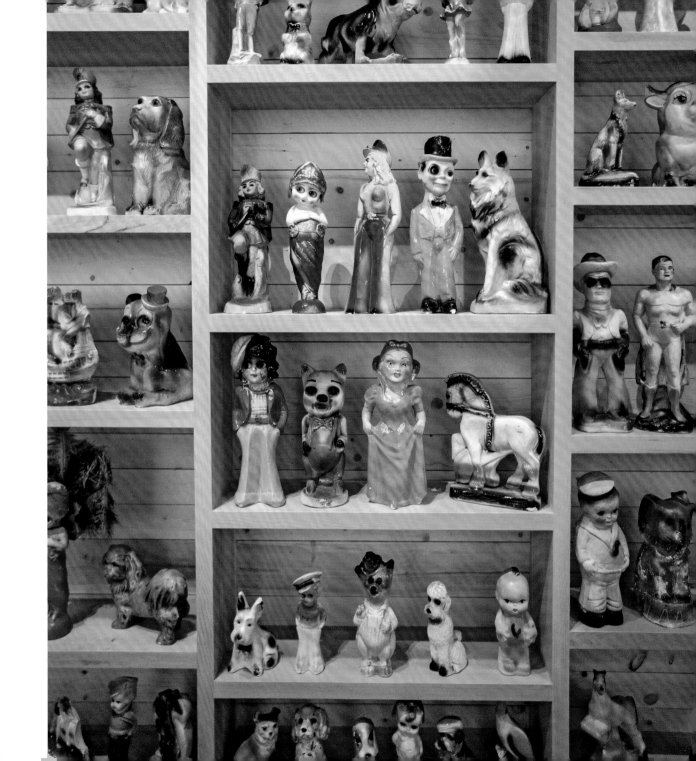

I DON'T KNOW WHAT IT IS ABOUT
COLLECTING, BUT I LOVE TO COLLECT
THINGS. I'LL NEVER STOP.

Dale Chihuly reviewing postcard collection
The Boathouse, Seattle, 2002

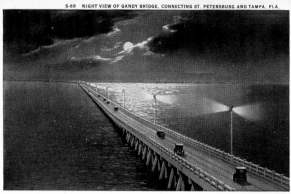

S-69 NIGHT VIEW OF GANDY BRIDGE, CONNECTING ST. PETERSBURG AND TAMPA, FLA.

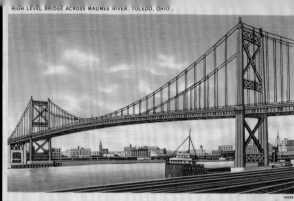

HIGH LEVEL BRIDGE ACROSS MAUMEE RIVER, TOLEDO, OHIO.

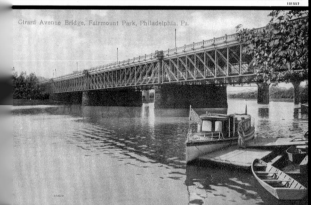

Girard Avenue Bridge, Fairmount Park, Philadelphia, Pa.

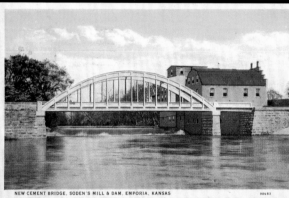

NEW CEMENT BRIDGE, SODEN'S MILL & DAM, EMPORIA, KANSAS

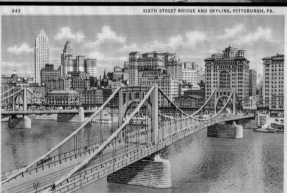

643 SIXTH STREET BRIDGE AND SKYLINE, PITTSBURGH, PA.

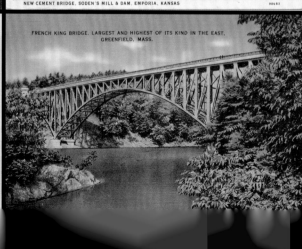

FRENCH KING BRIDGE, LARGEST AND HIGHEST OF ITS KIND IN THE EAST, GREENFIELD, MASS.

Postcards were such a quick way to correspond. I particularly like the beautiful hand-colored ones, and I love reading the notes people wrote on the back side. Some of my favorite subjects are bridges, lighthouses, and conservatories.

114 *Lake Washington Floating Bridge, Seattle, Washington*

2B-H349

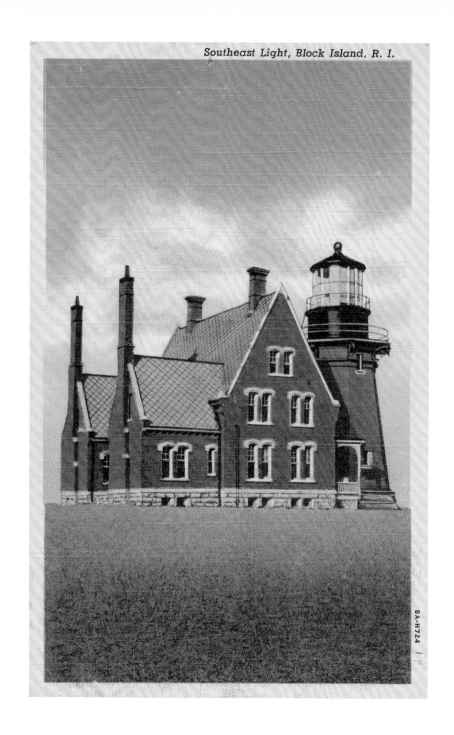

Southeast Light, Block Island, R. I.

8A-H724

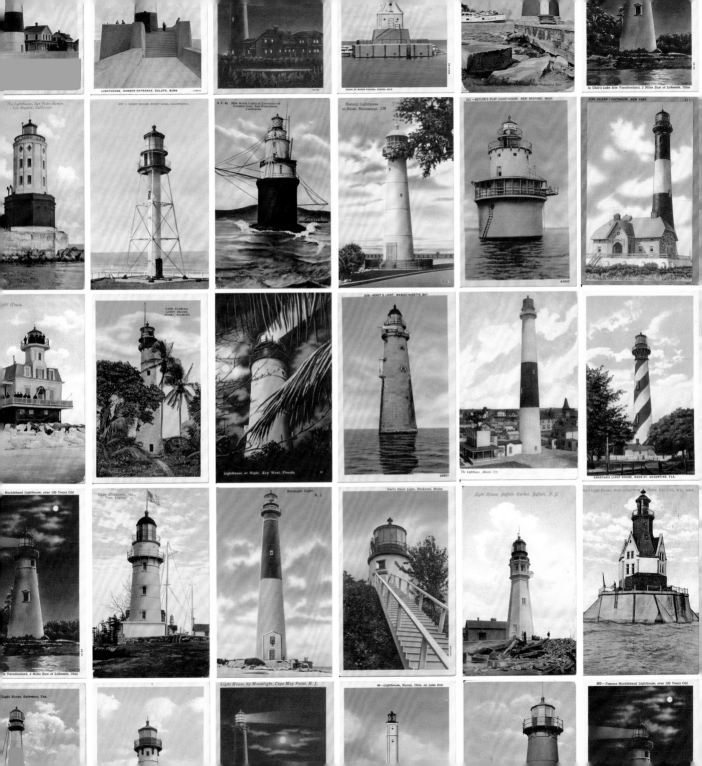

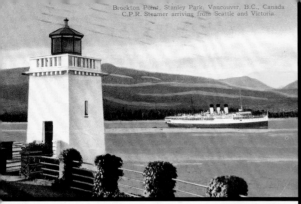

Brockton Point, Stanley Park, Vancouver, B.C. Canada
C.P.R. Steamer arriving from Seattle and Victoria.

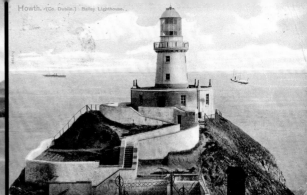

Howth. (Co. Dublin.) Bailey Lighthouse.

95—Point Pinos Light House, Pacific Grove, California

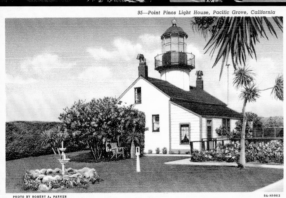

PHOTO BY ROBERT A. PARKER 3A-H3963

(k202) (行發局書商生共鮮) Light House of Wada point, Kobe 神戸和田岬の燈臺

O-17—Bray's Point and Lighthouse at the Junction of Fox River and Lake Winnebago, Oshkosh, Wis.

9A-H2000

HABANA: CASTILLO DEL MORRO

HAVANA: MORRO CASTLE 0B-H1119

547—NORTH HEAD LIGHT HOUSE ILLUMINATING COAST OF WASHINGTON

© WESLEY ANDREWS

8A-H118

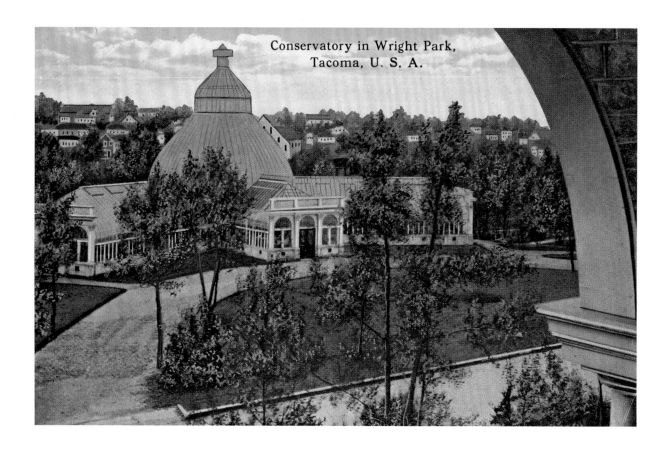

Conservatory in Wright Park,
Tacoma, U. S. A.

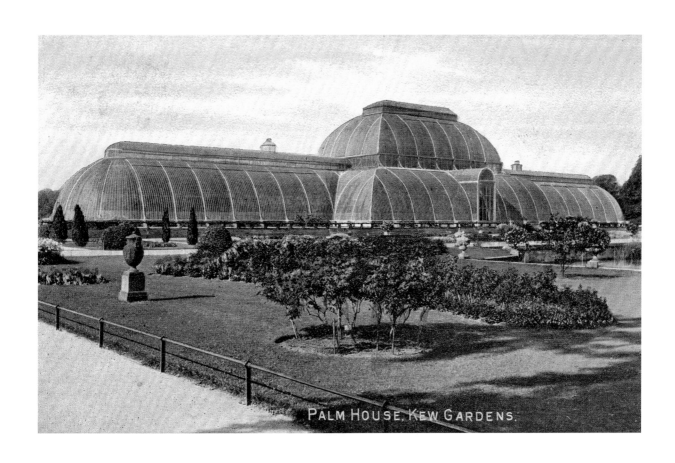

PALM HOUSE, KEW GARDENS.

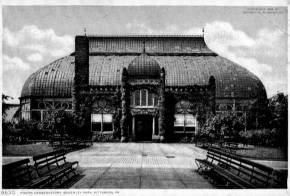

9630. PHIPPS CONSERVATORY, SCHENLEY PARK, PITTSBURG, PA.

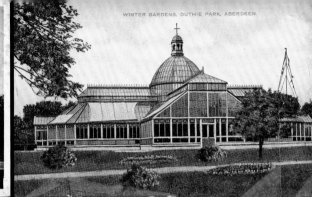

WINTER GARDENS, DUTHIE PARK, ABERDEEN.

Conservatory, Mitchell Park, Milwaukee, Wis.

Flower Garden and Conservatory,
Washington Park, Chicago.

327:—INTERIOR CONSERVATORY, PROSPECT PARK, BROOKLYN, N. Y.

The Conservatory, Duke's Park, Somerville, N.J.

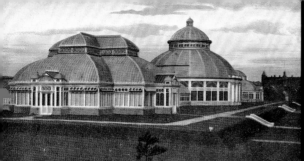

Conservatory, Bronx Park, New York.

96-68

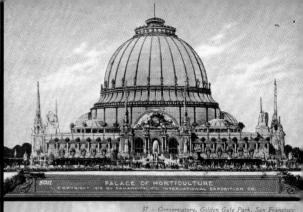

5011 PALACE OF HORTICULTURE
COPYRIGHT 1915 BY PANAMA-PACIFIC INTERNATIONAL EXPOSITION CO.

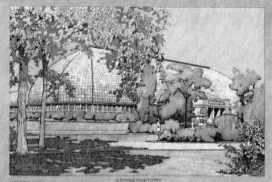

ART LOVERS CHICAGO

CONSERVATORY
GARFIELD PARK

VOLLAND VIEWS

37 - Conservatory, Golden Gate Park, San Francisco

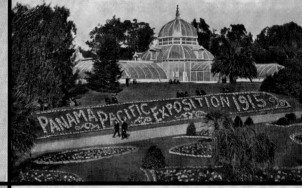

PANAMA PACIFIC EXPOSITION 1915

THE JEWEL BOX, FOREST PARK, ST. LOUIS, MO.—3

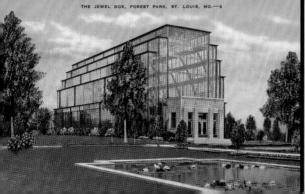

31—Conservatory and Bird House at Zoo, Overton Park, Memphis, Tenn.

I just love trailers. Years ago, I spent some time driving around the Southwest photographing trailer parks with the idea of doing a book. I didn't do the book, but I did hire a craftsman to fabricate trailer birdhouses for my studio.

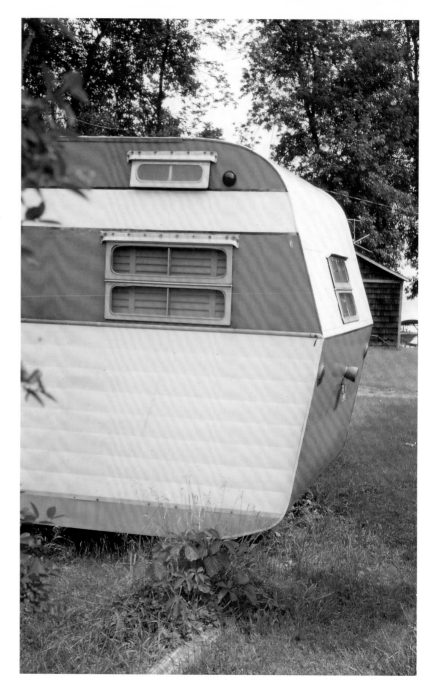

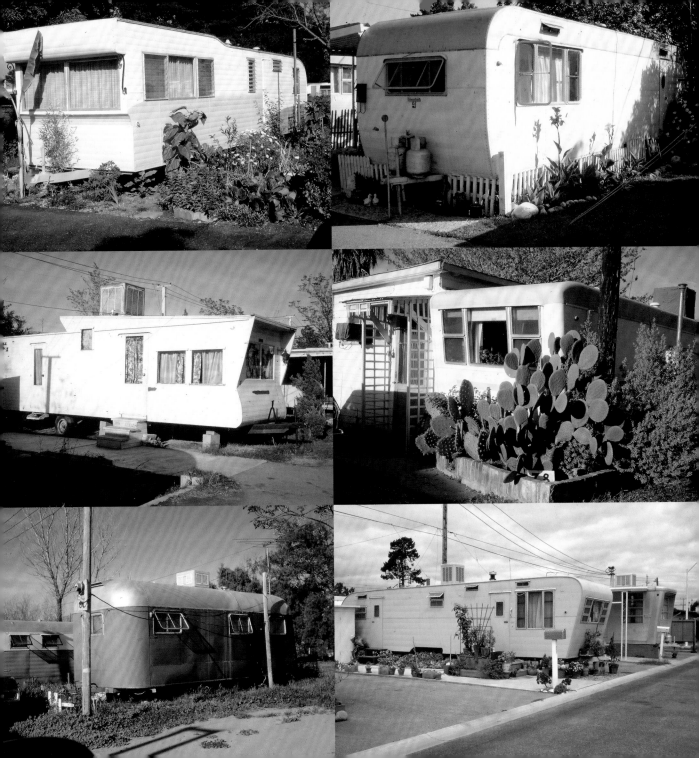

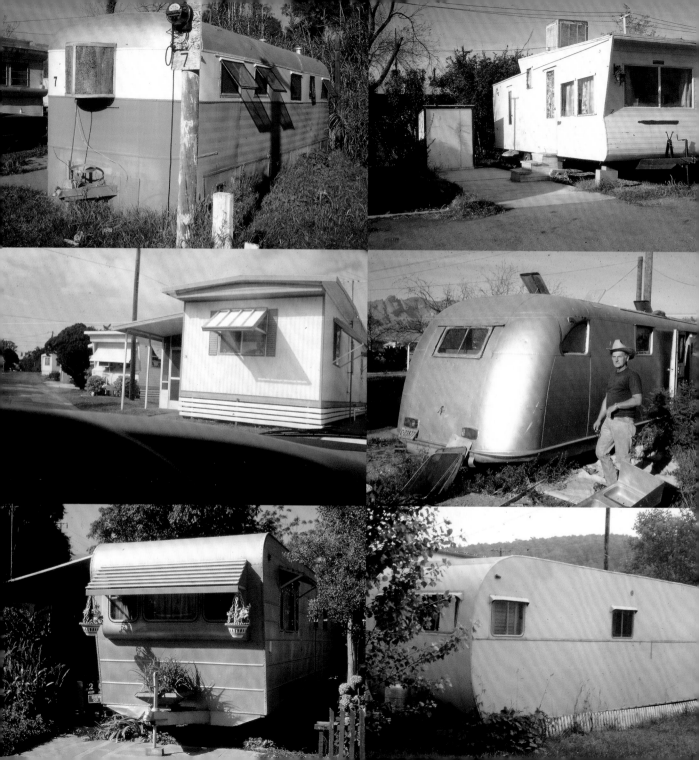

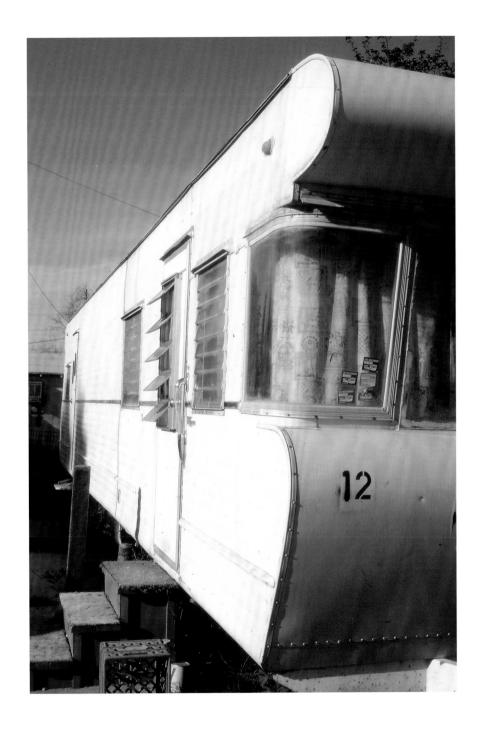

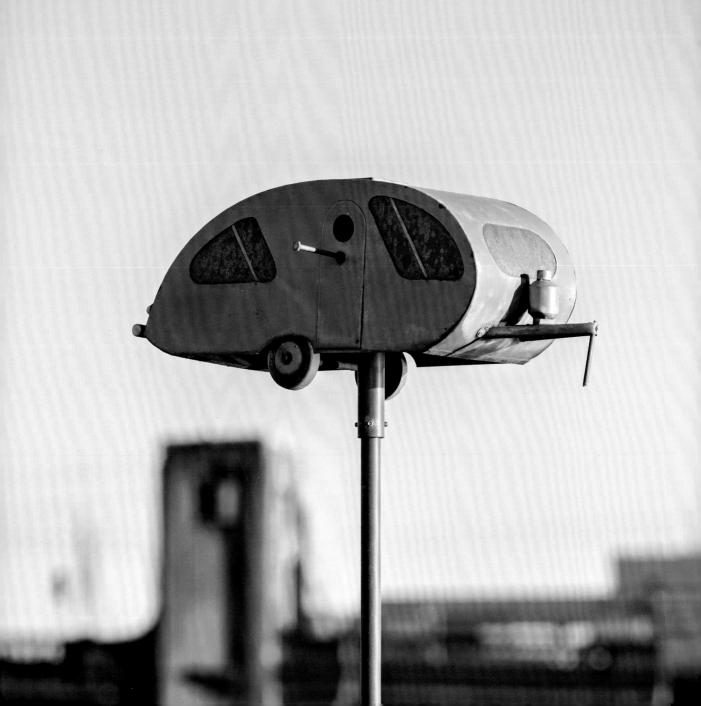

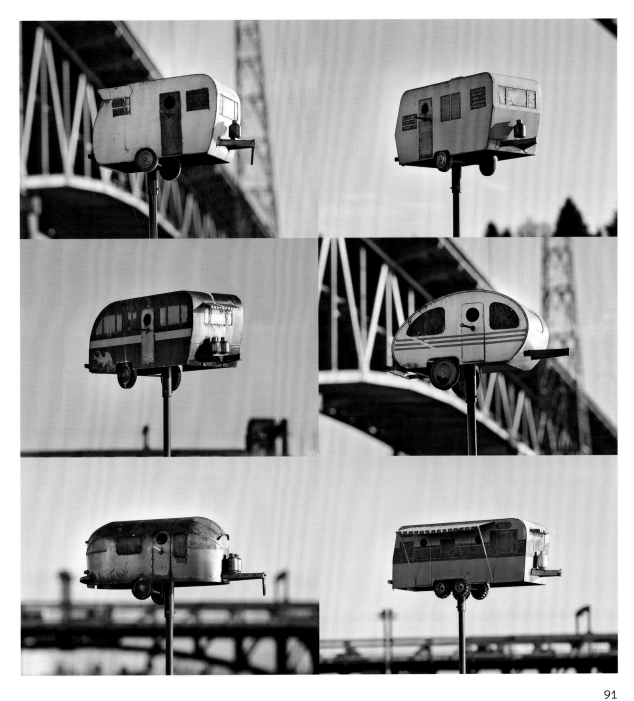

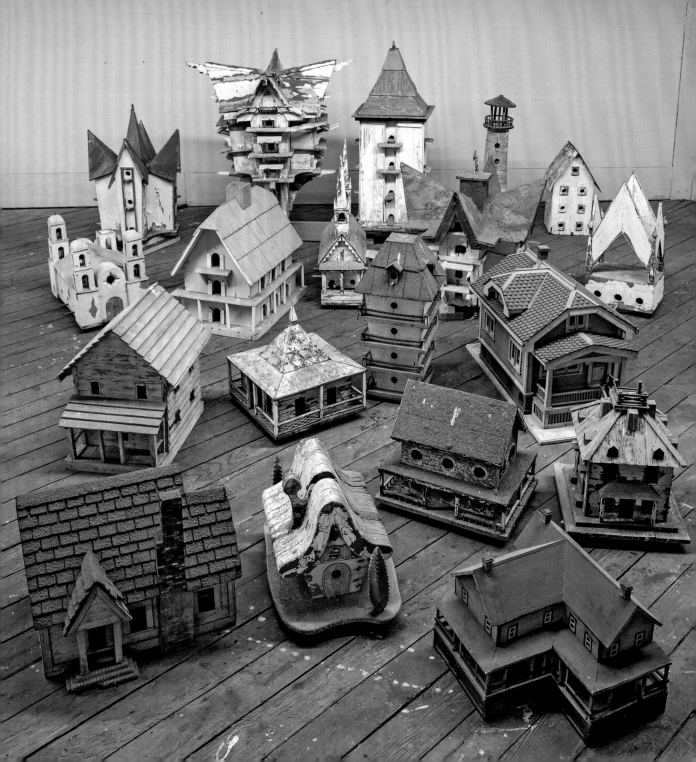

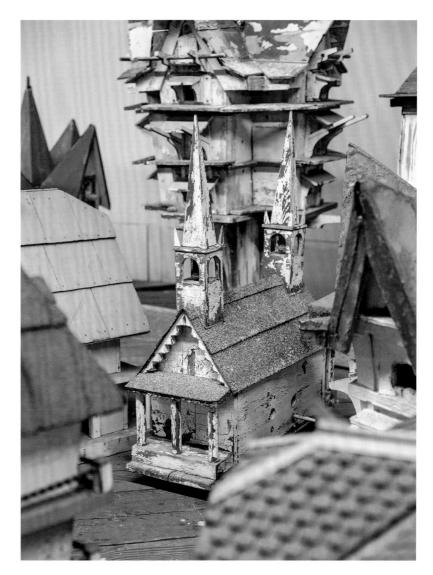

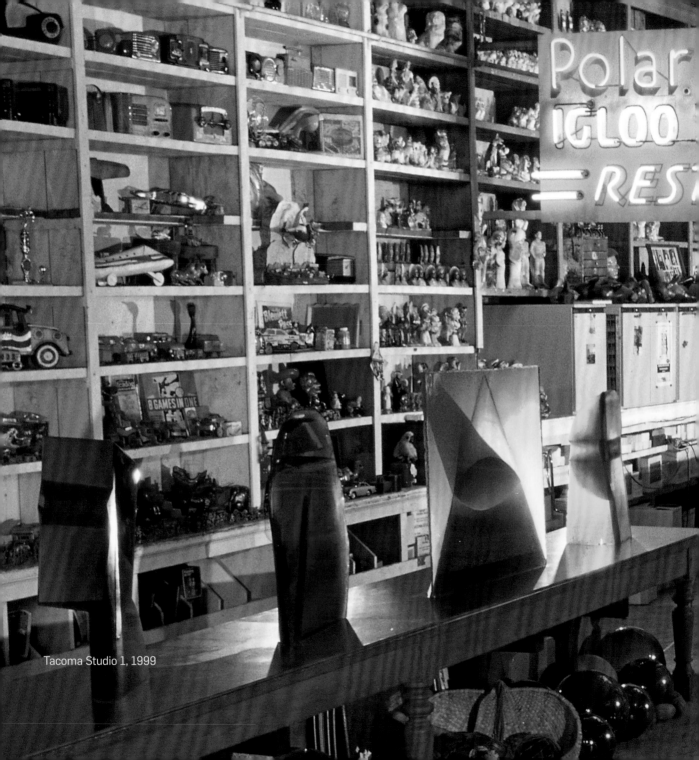

Tacoma Studio 1, 1999

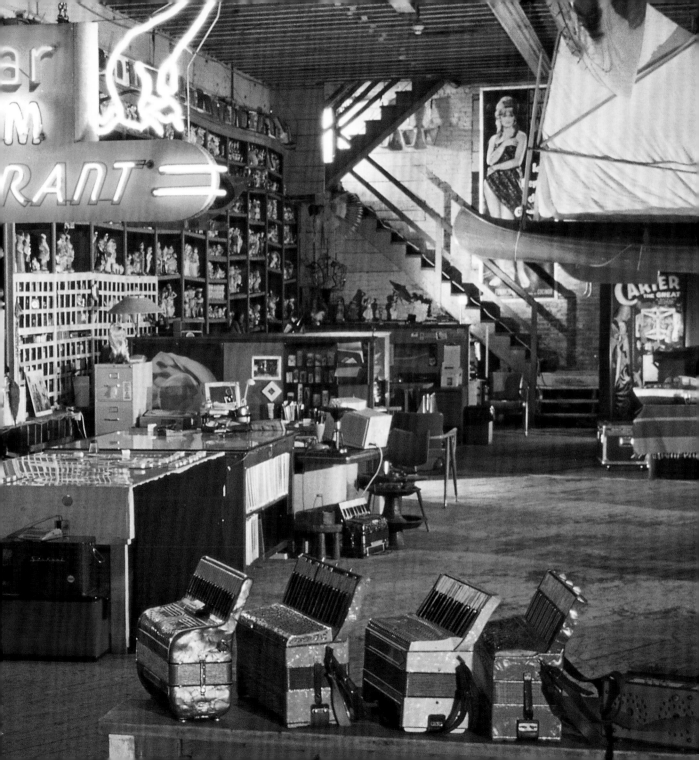

For years I kept my collections in my Tacoma Studio 1. I liked to lay things out there where I could see it all. That helped me decide where I wanted things to go next.

Tacoma Studio 1, 1999

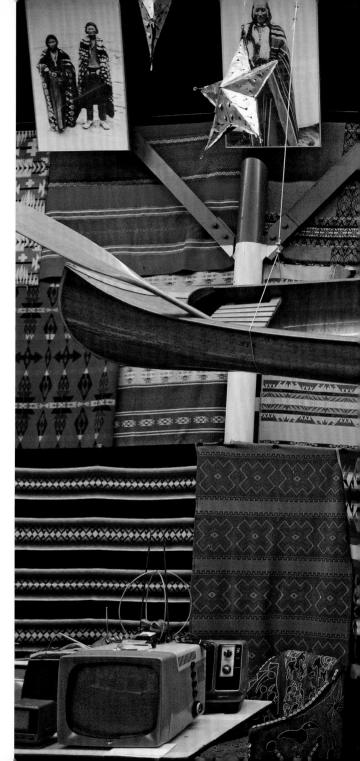

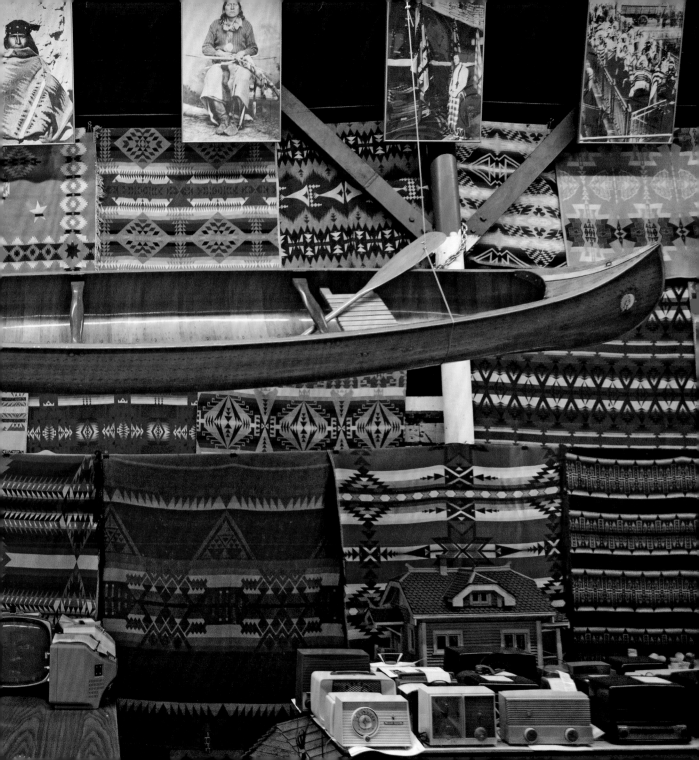

The canoe is such an extraordinary form as it moves across the water. I look for beautiful wooden canoes, and I hang them from the ceiling.

Tacoma Studio 1, 1999

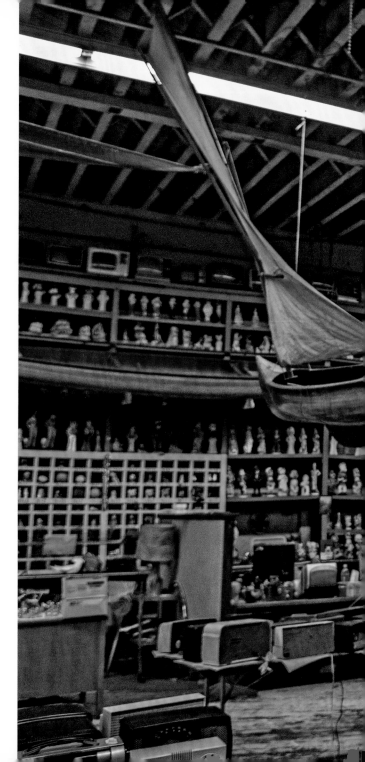

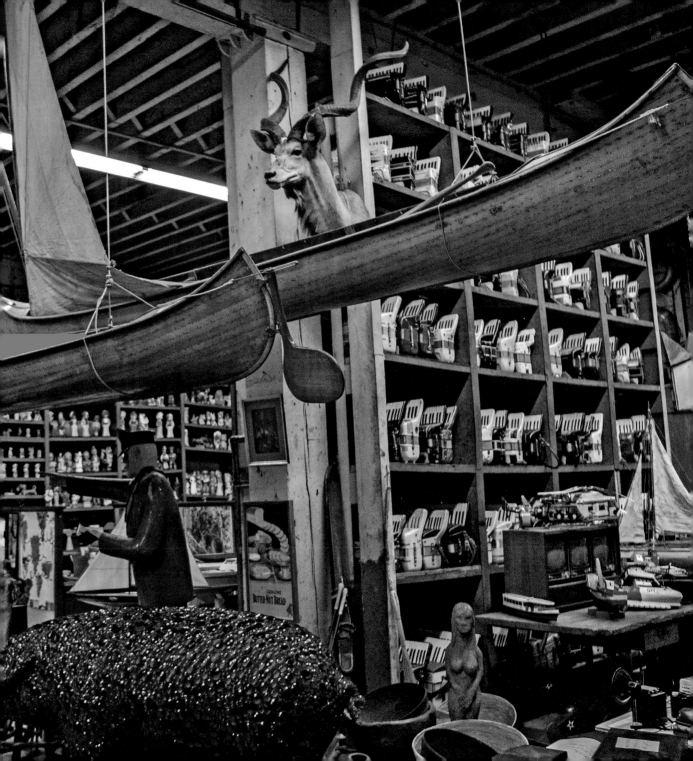

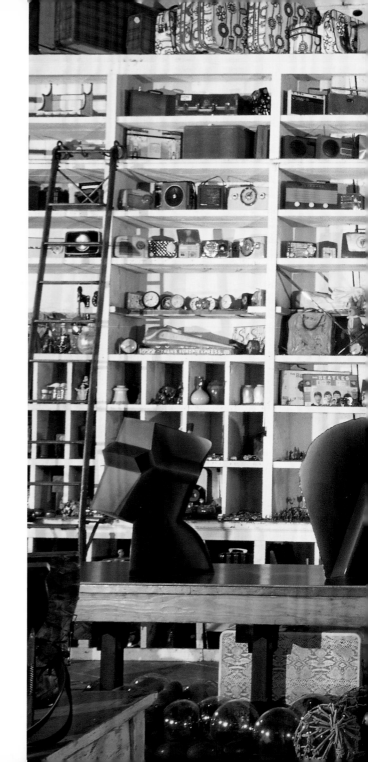

Cast-glass sculptures by Stanislav
Libenský and Jaroslava Brychtová
Tacoma Studio 1, 1999

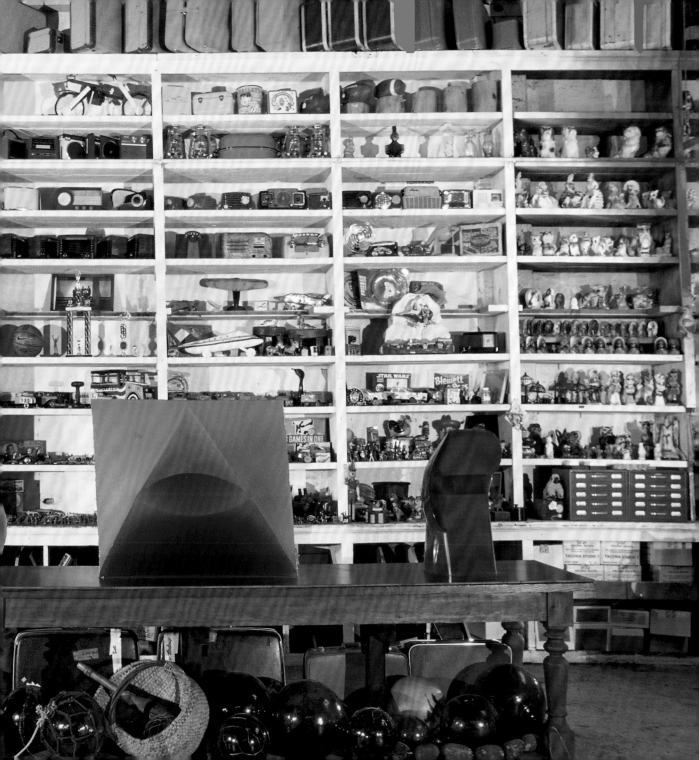

WHEN I WAS A KID, SHOOTING MARBLES WAS POPULAR. WE PLAYED FOR KEEPS. AFTER I PICKED THE KEEPERS FOR MY COLLECTION, MOM WOULD HELP ME SEW UP LITTLE BAGS. I WOULD PUT THE CULLS INTO THOSE AND SELL THEM BACK TO MY FRIENDS FOR A NICKEL A BAG.

Dale, Tacoma, Washington, 1951

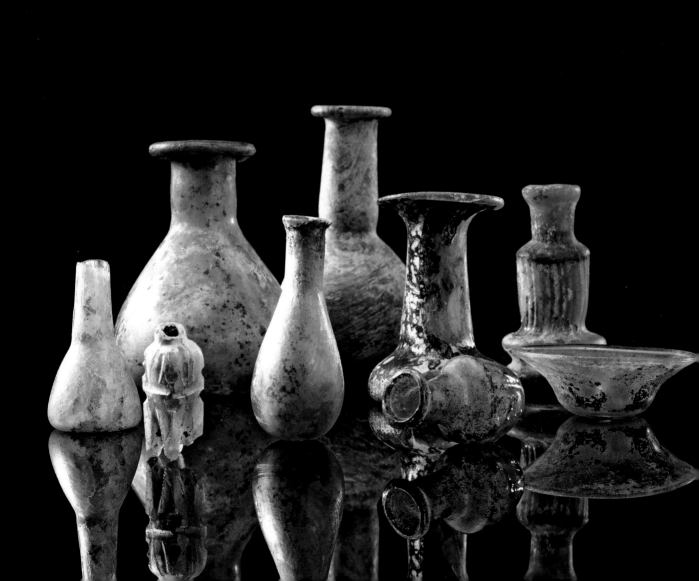

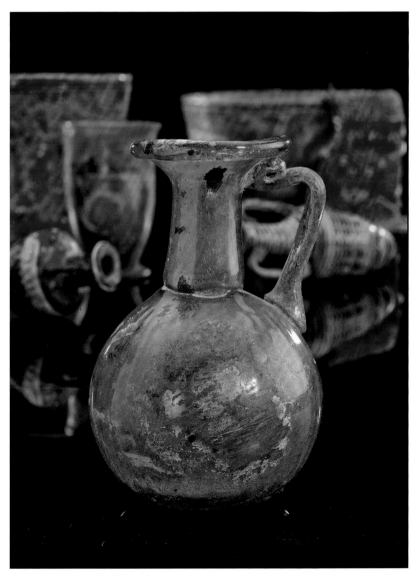

I love the patina that only time and age can give the surface of an object. These are some of the earliest examples of handblown glass, made from 100 BC to AD 400, mainly during the Roman Empire.

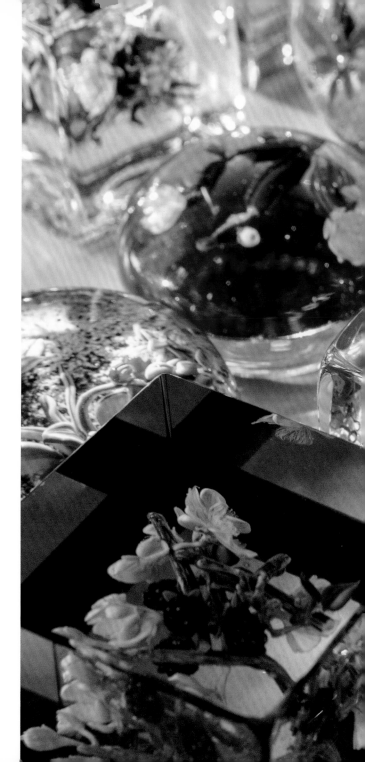

Glass paperweights by
Paul Stankard

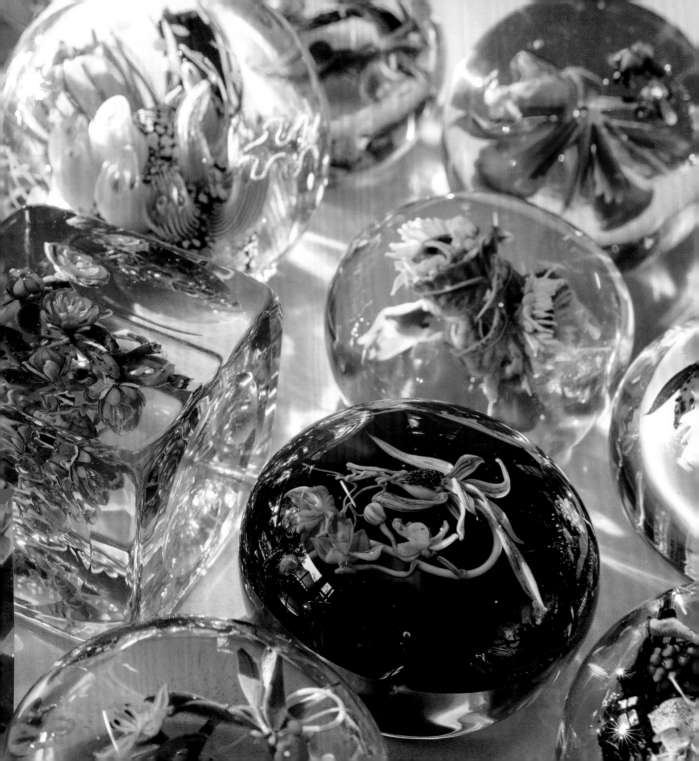

In 1996, I acquired a building in the Ballard neighborhood of Seattle. I needed a bigger space where we could mock up my large installations. It is where I do my drawings and paintings. It is where a big part of my team and I go to work every day. I have a studio upstairs where I like to write letters, work on my stamp projects, and have meetings surrounded by my books and a few of my collections.

Dale's studio, Seattle

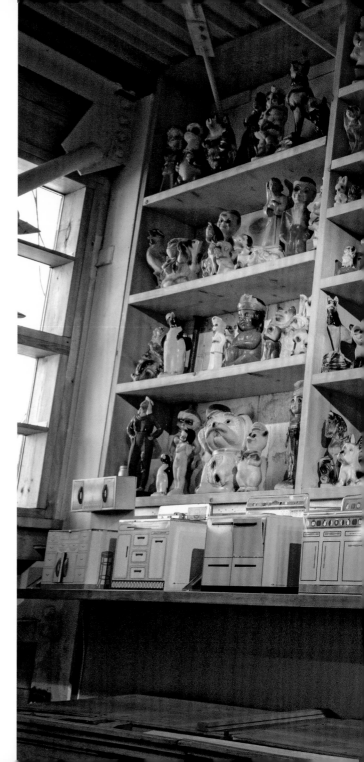

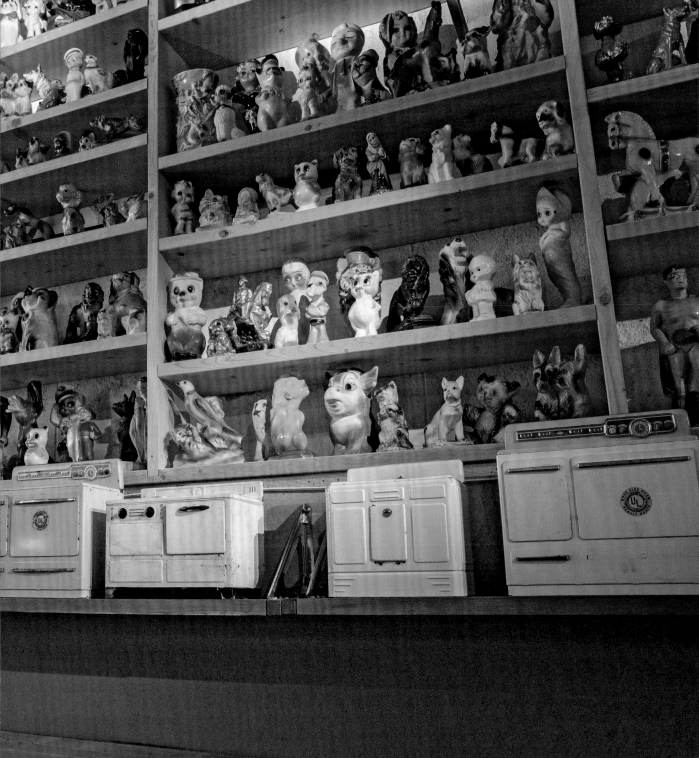

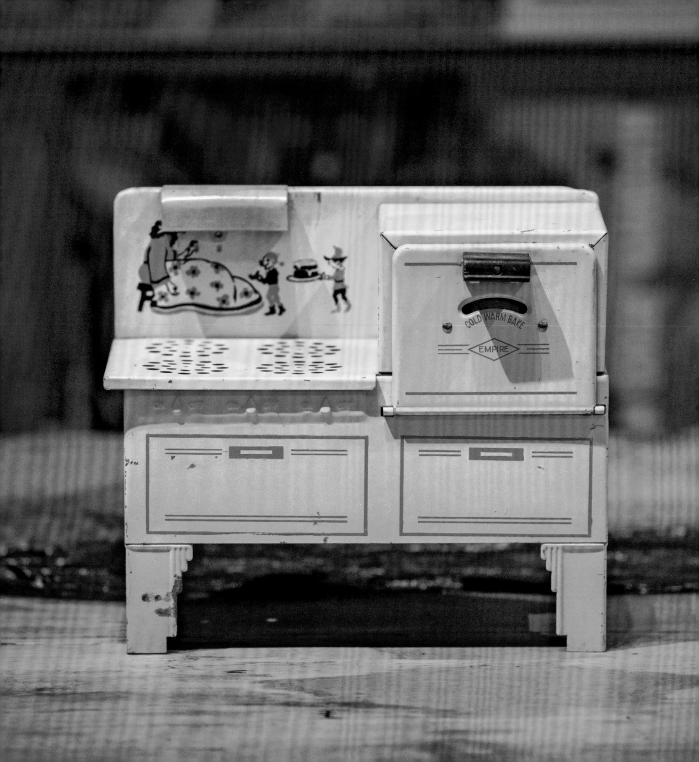

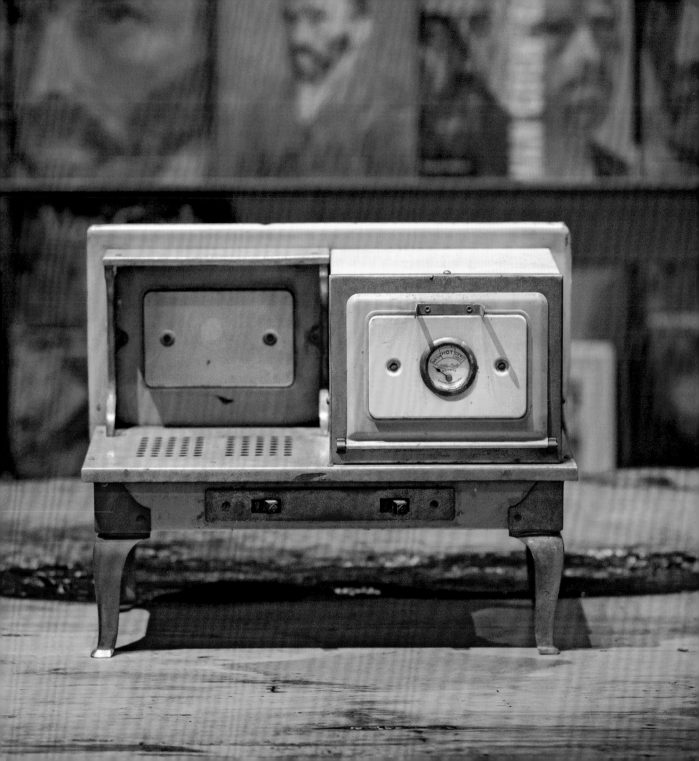

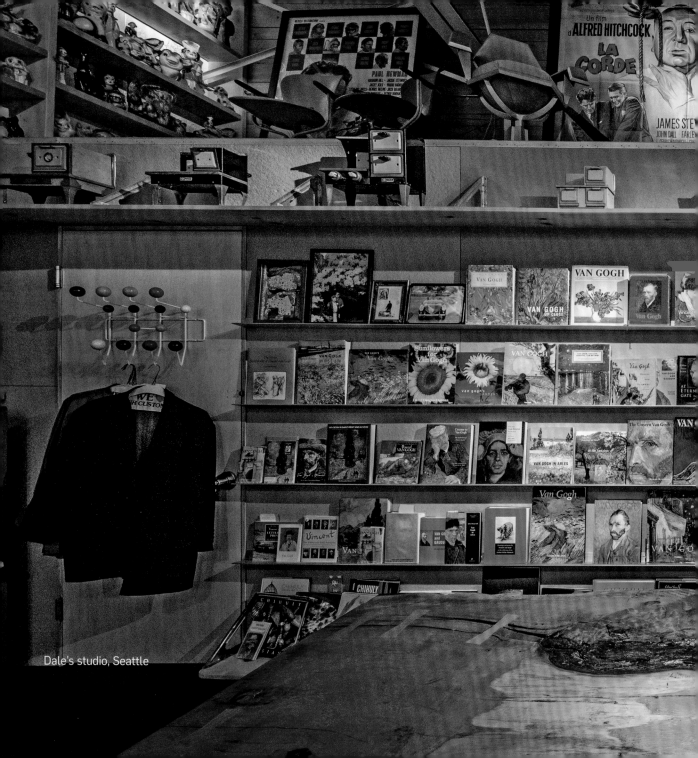

Dale's studio, Seattle

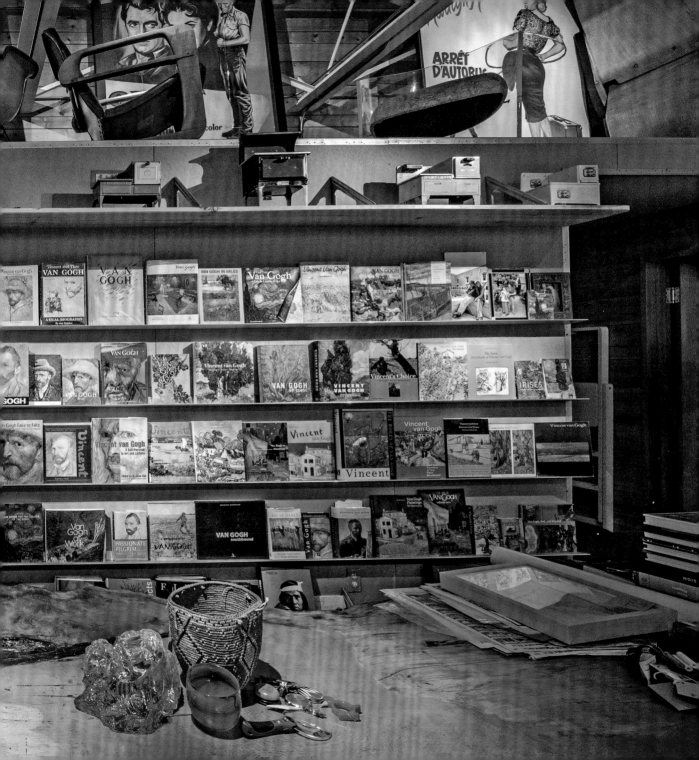

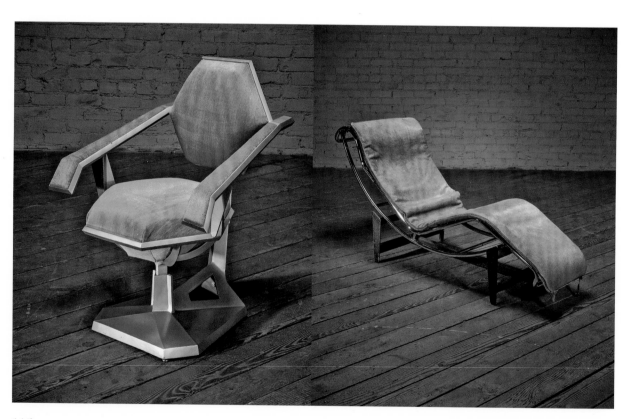

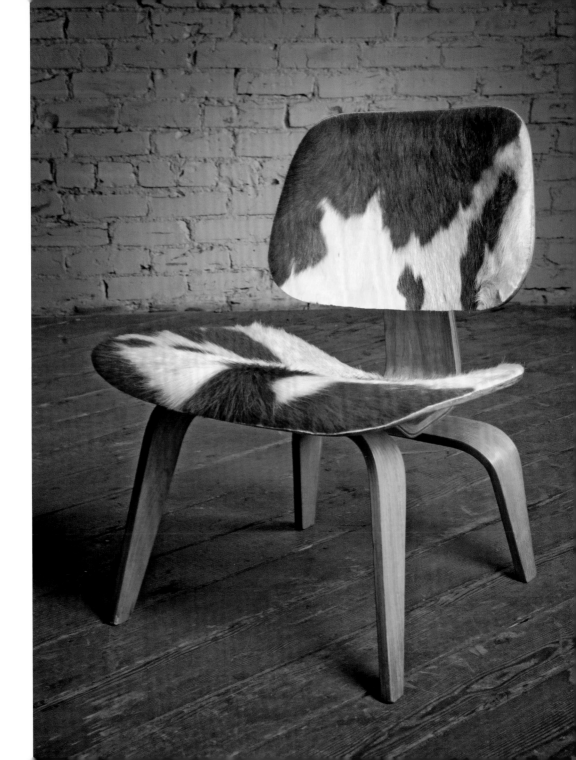

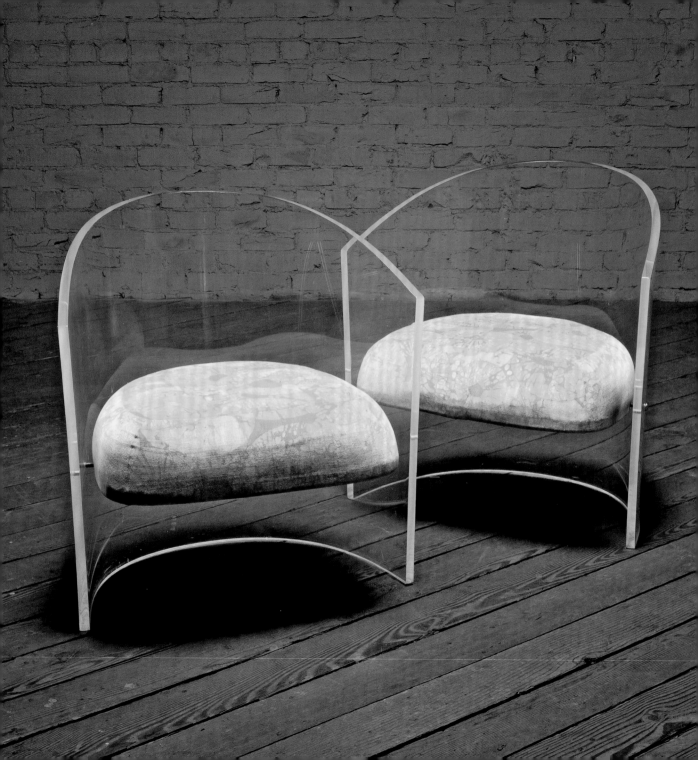

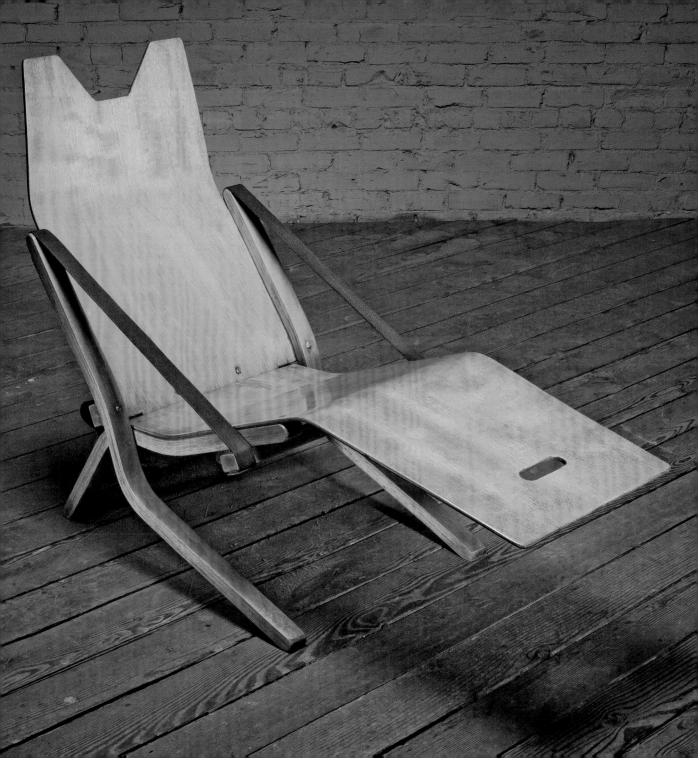

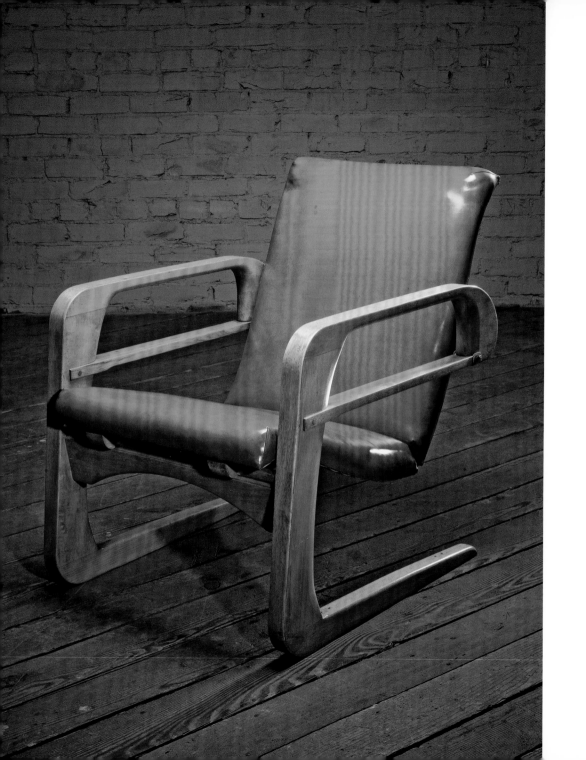

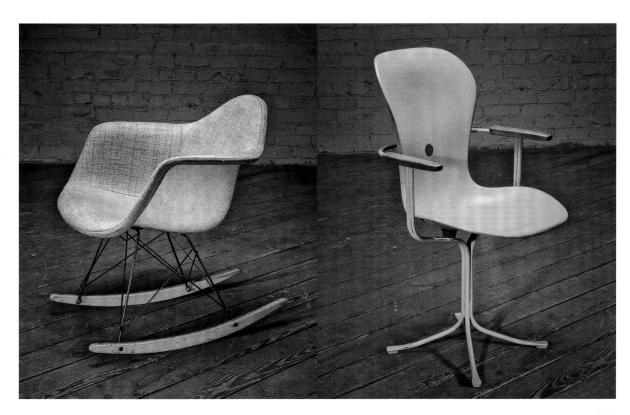

One of my first collections as a kid was stamps, and I still enjoy them. I don't use e-mail and prefer sending handwritten letters and postcards to friends. I sketch on the envelopes and mail them with stamps from past decades. There are some great designs on those old commemorative stamps.

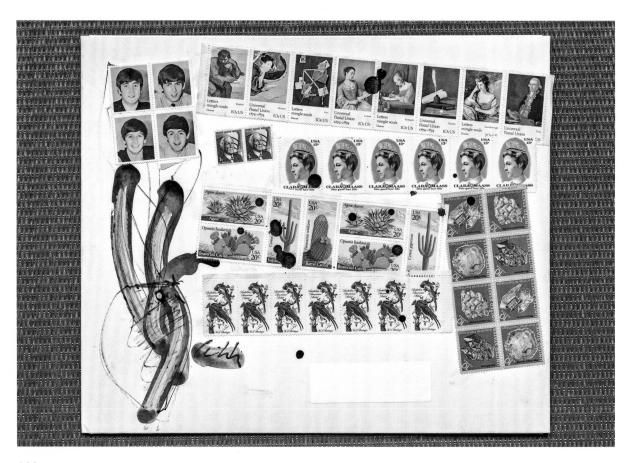

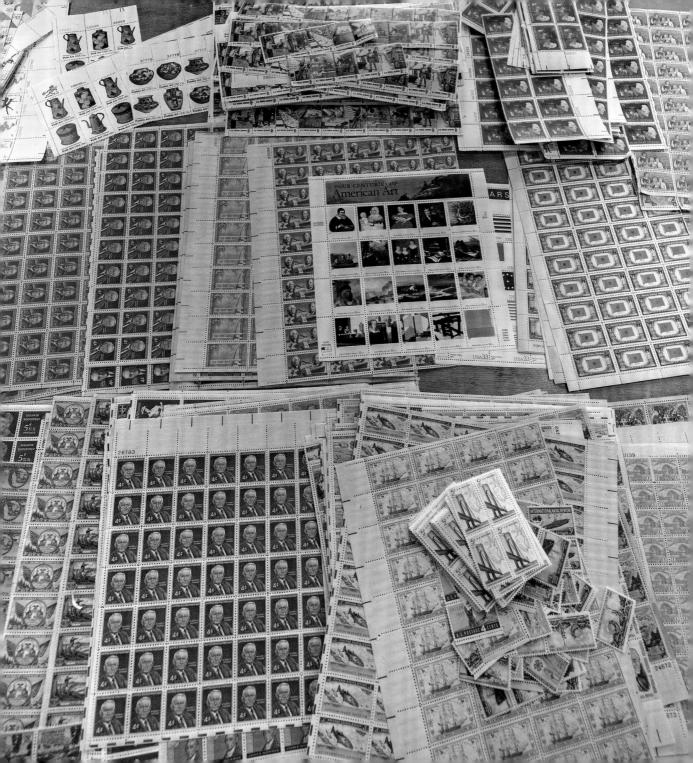

MY COLLECTIONS INSPIRE ME AND ARE OFTEN A SOURCE FOR NEW IDEAS.

Chihuly and Benjamin Moore
Rhode Island School of Design,
Providence, 1976

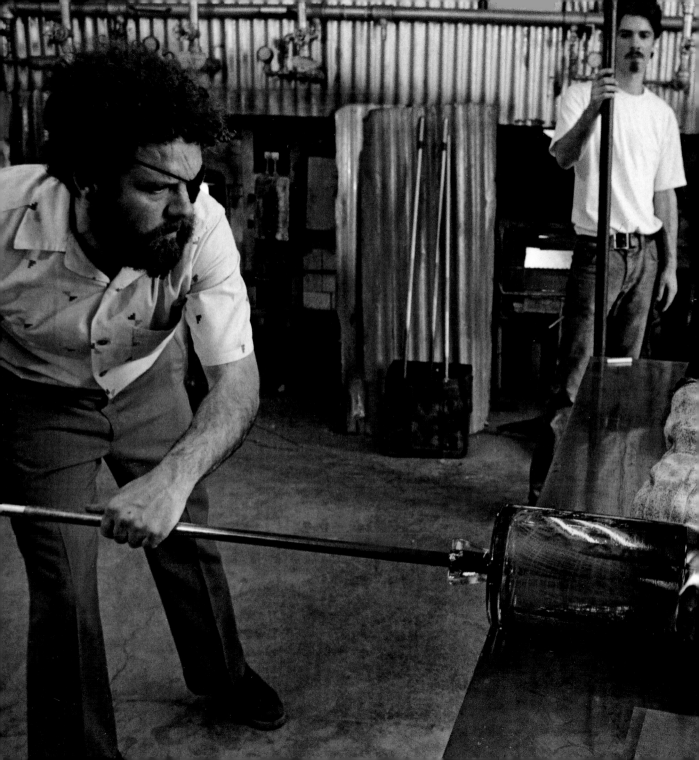

Under the wall of colored glass samples is a collection of metal molds. We dip hot glass into them to get a variety of patterns on the surface. Some of the molds are commercially available, but many of these have been custom-made in different shapes and sizes for my projects.

The Boathouse hotshop, Seattle

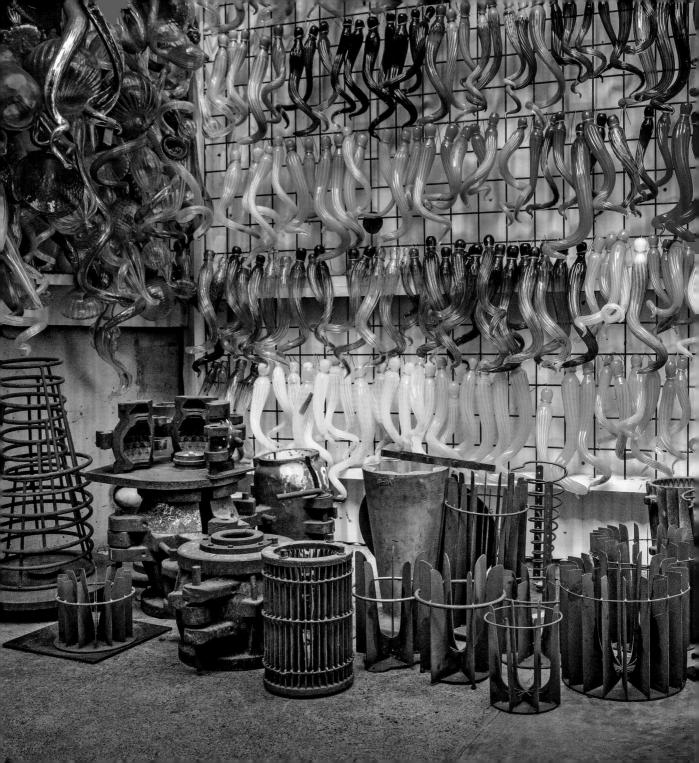

In the Boathouse hotshop, we have a collection of 300 glass color rods, which make up our palette for glassblowing. They come from Europe—mostly from Germany.

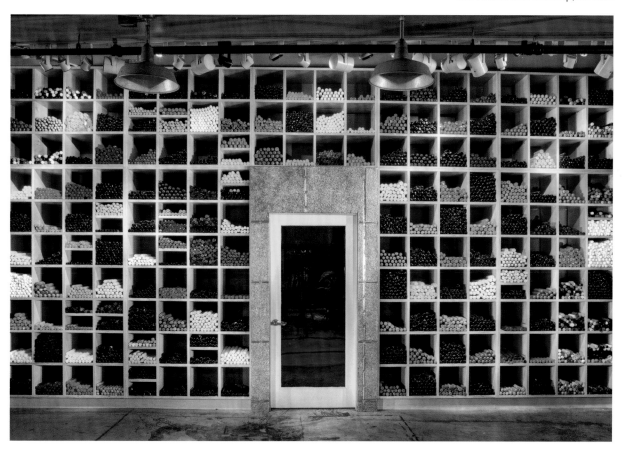

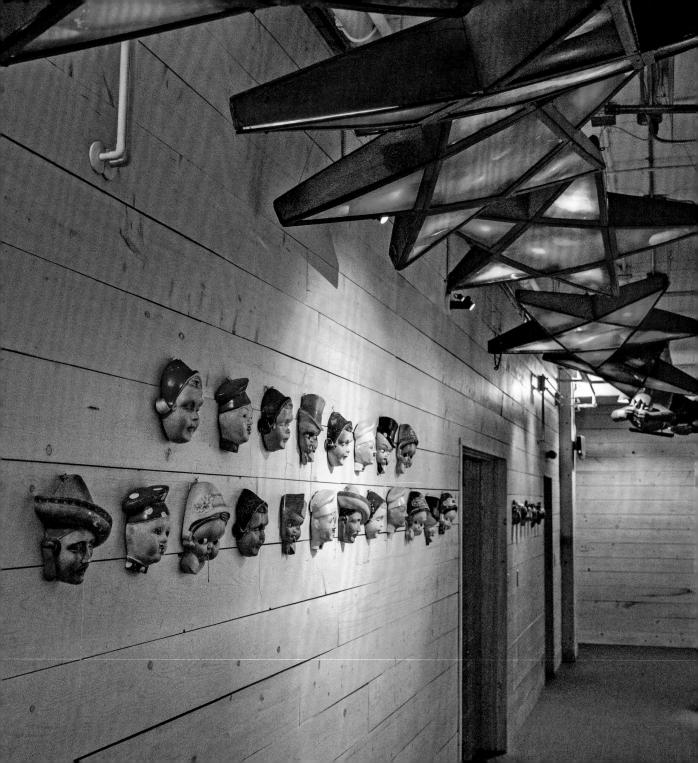

The Boathouse is in a constant state of change.
I bought the 25,000-square-foot Pocock Building
on Lake Union in 1990, and I have been working
on it ever since. I lived there for many years. The
Boathouse is where all of the glassblowing happens.
I work with my team on new projects, ideas, and
experiments there.

The Boathouse, Seattle

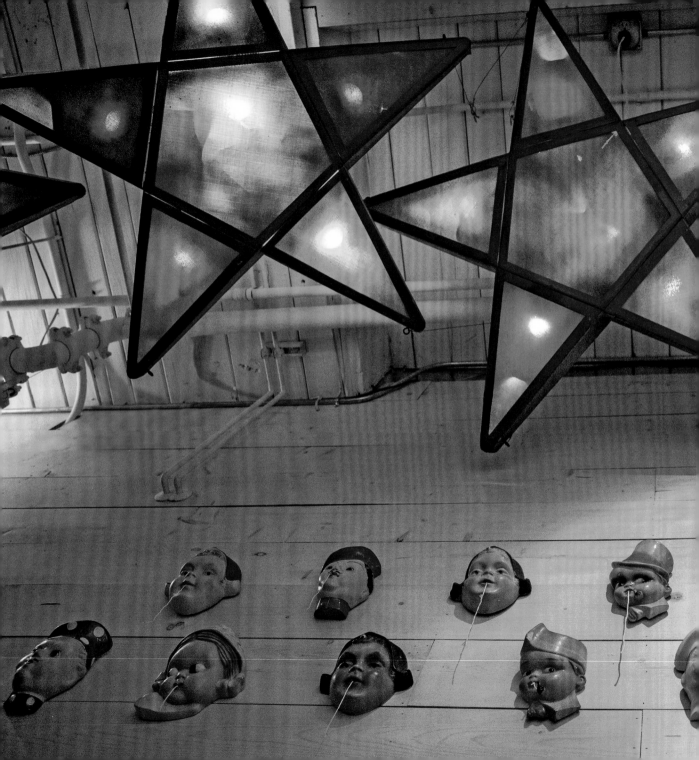

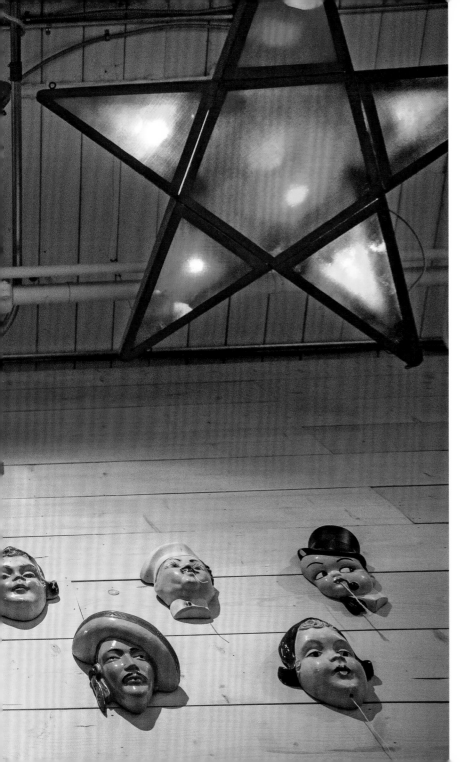

I hung some dance-hall star lights from the 1920s in the hallway.

The Boathouse, Seattle

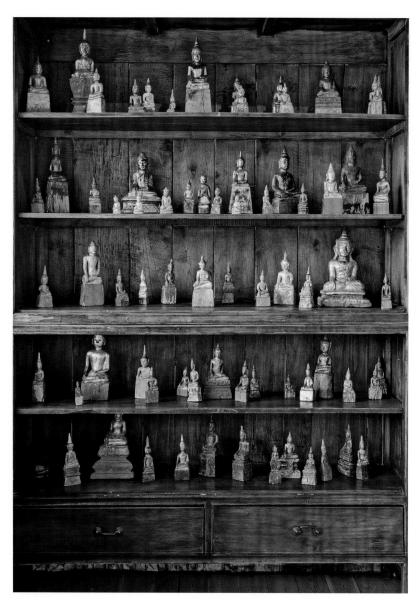

Evelyn Room
The Boathouse, Seattle

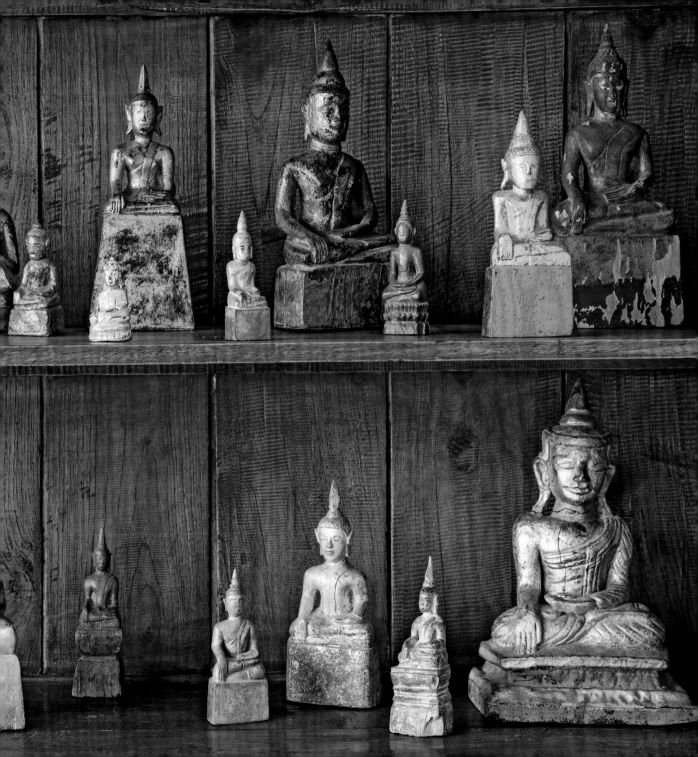

The papier-mâché masks
that I found in Tacoma
were probably used in
Mardi Gras parades.

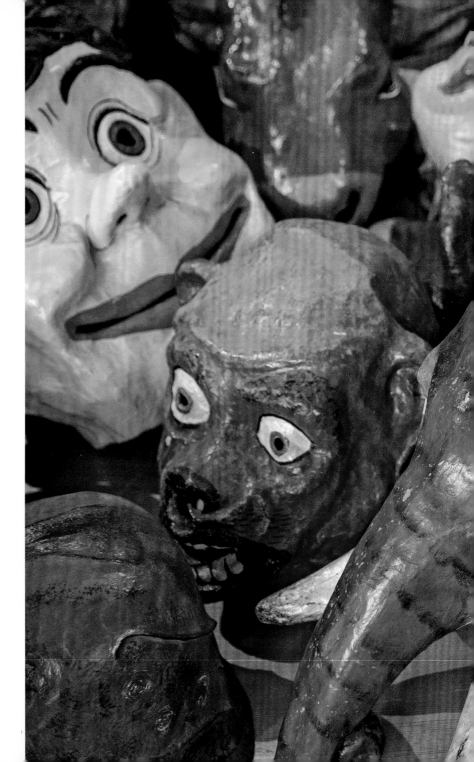

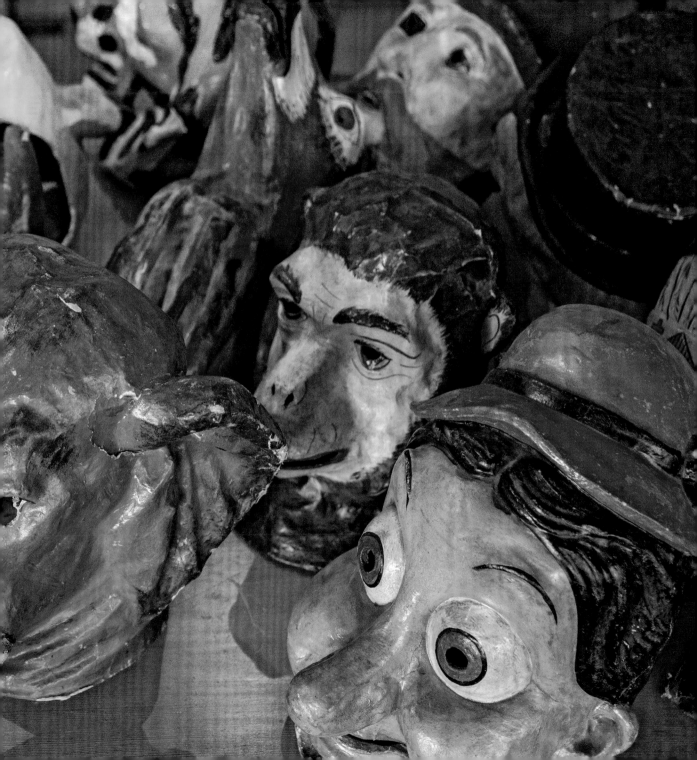

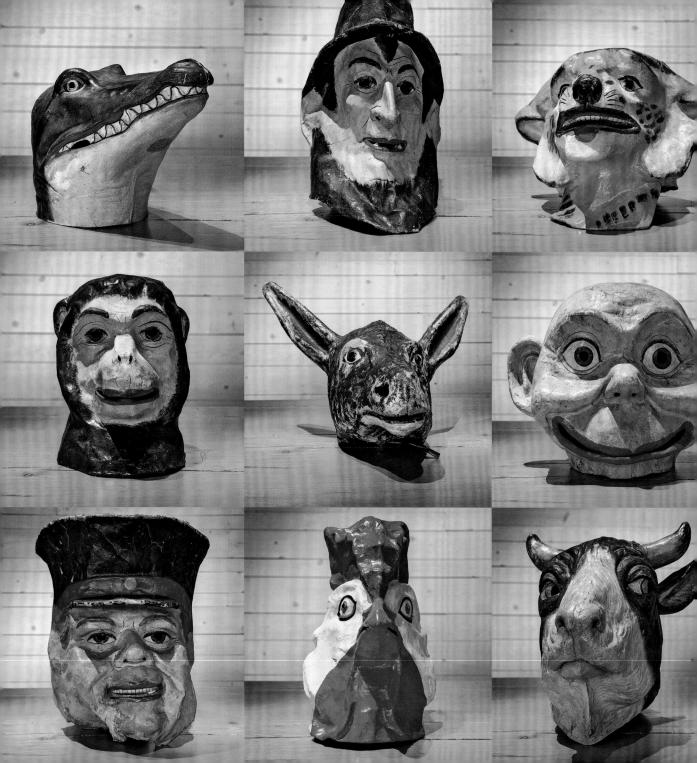

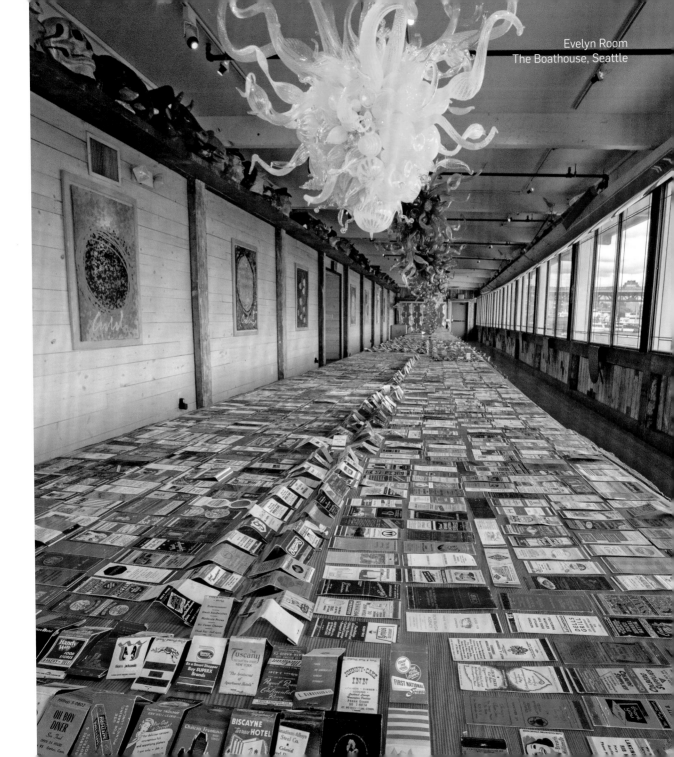

I never played the
accordion, but both my
big brother and my father
did. If I had to pick only
one instrument to hear,
it would be the accordion.

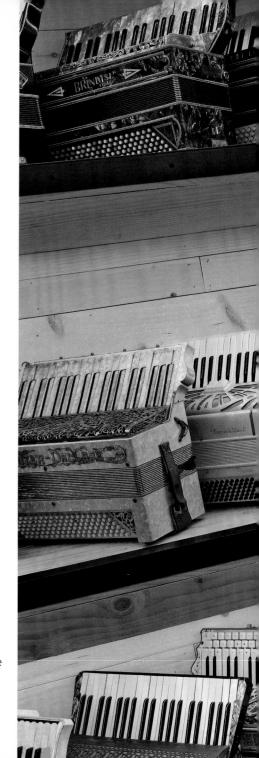

The Boathouse, Seattle

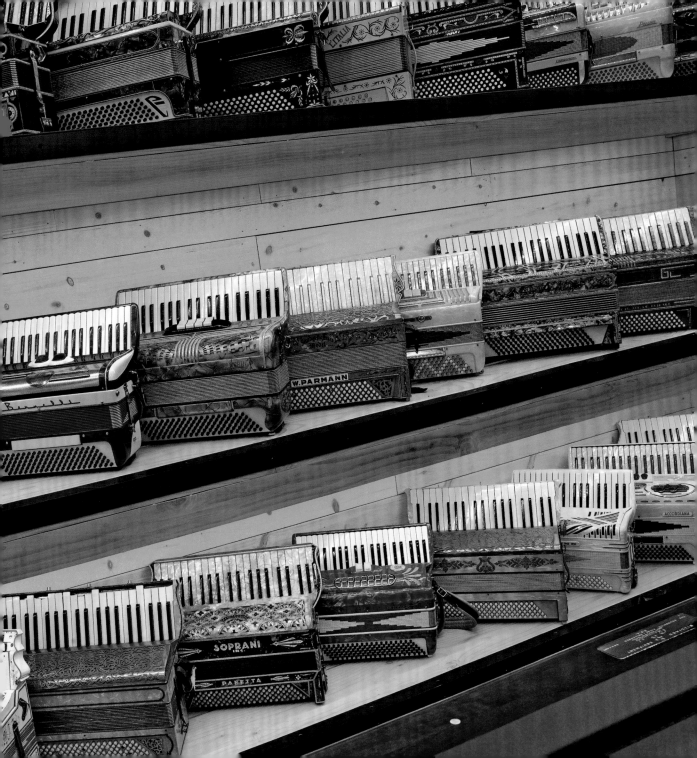

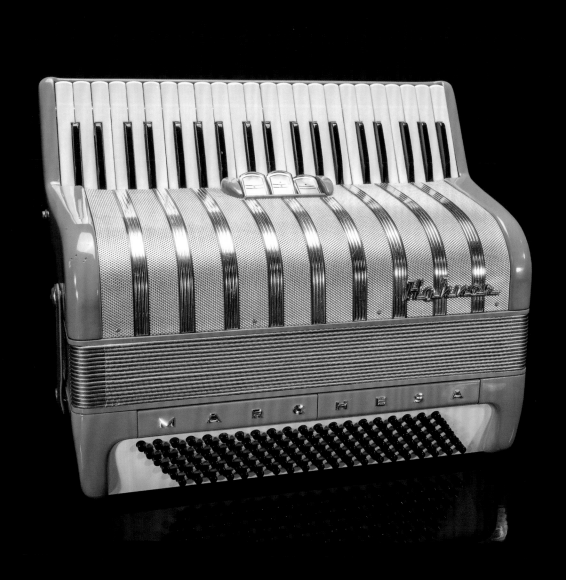

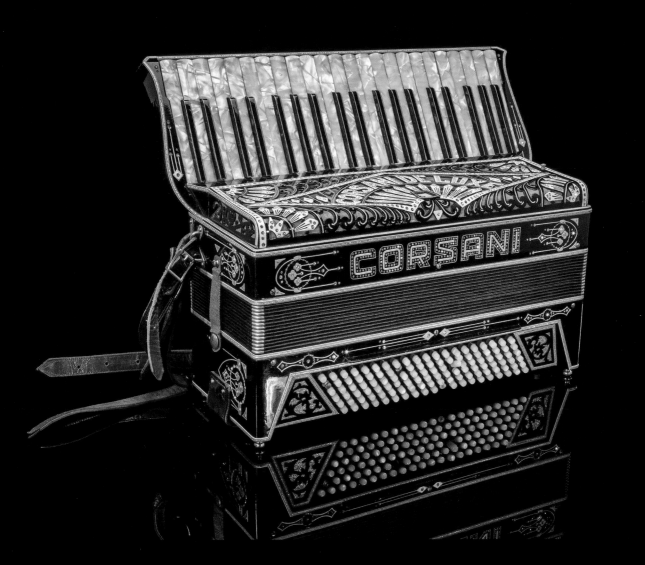

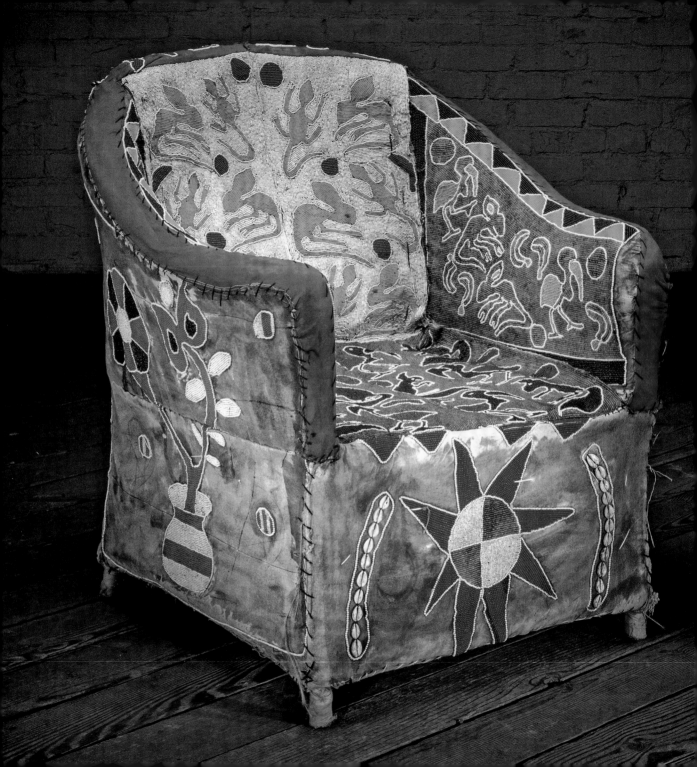

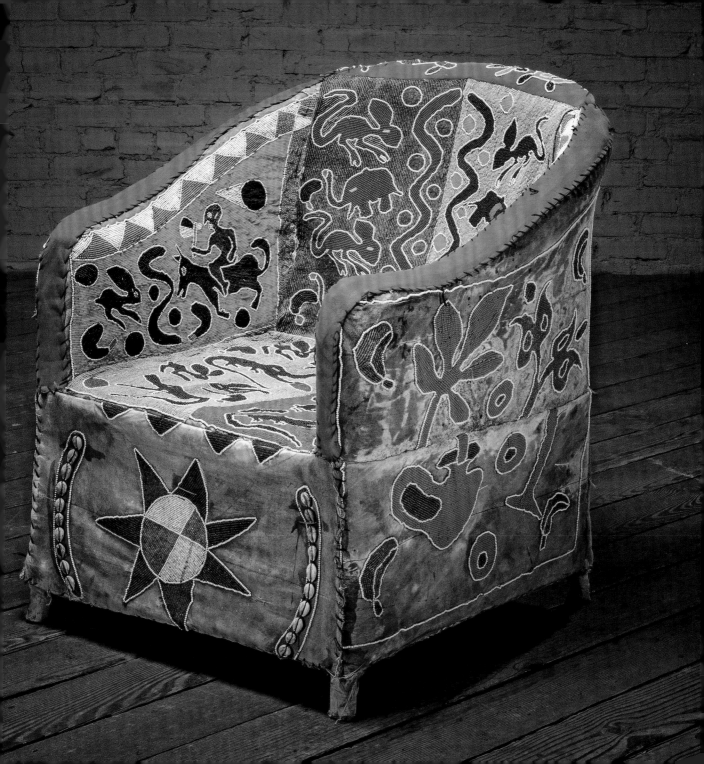

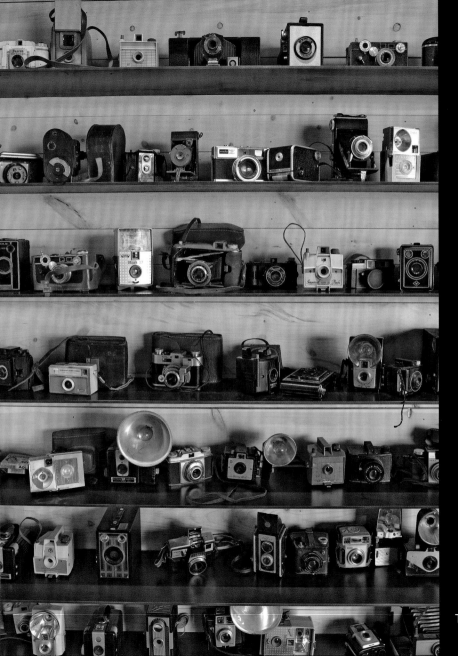

The Boathouse, Seattle

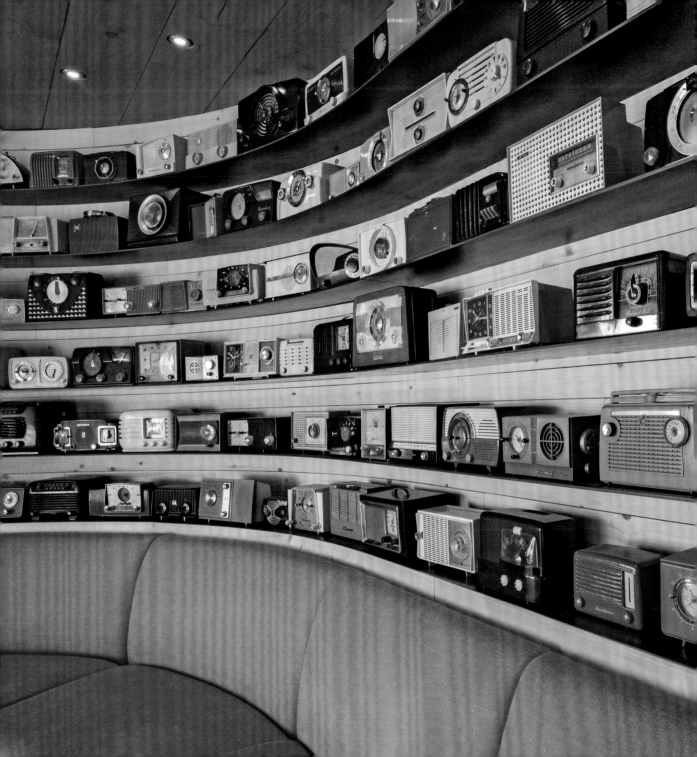

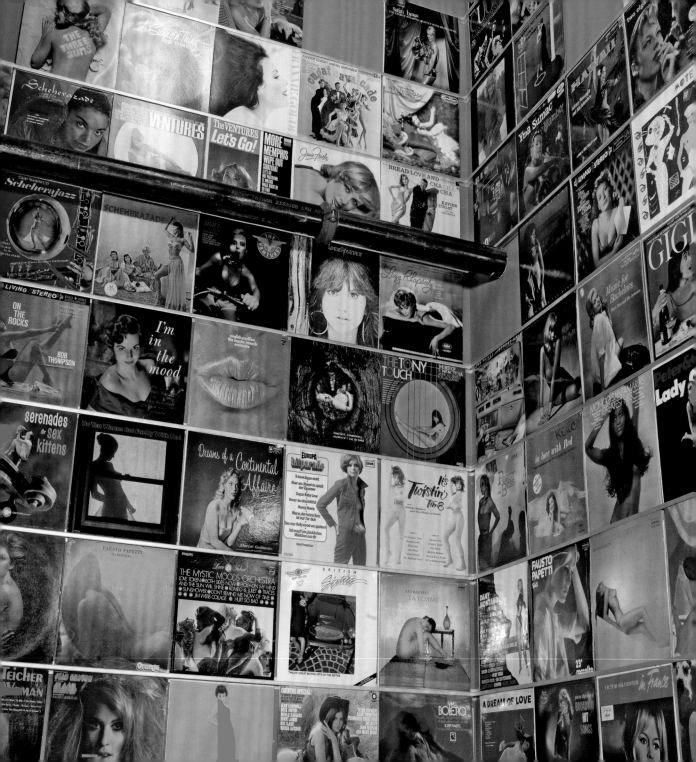

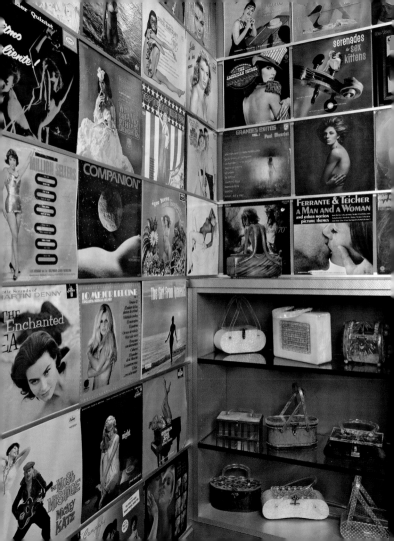

I like books, and I like the way they look. I'm the first to admit I often buy books for their covers. Art books are among my favorite things, and I like to display them.

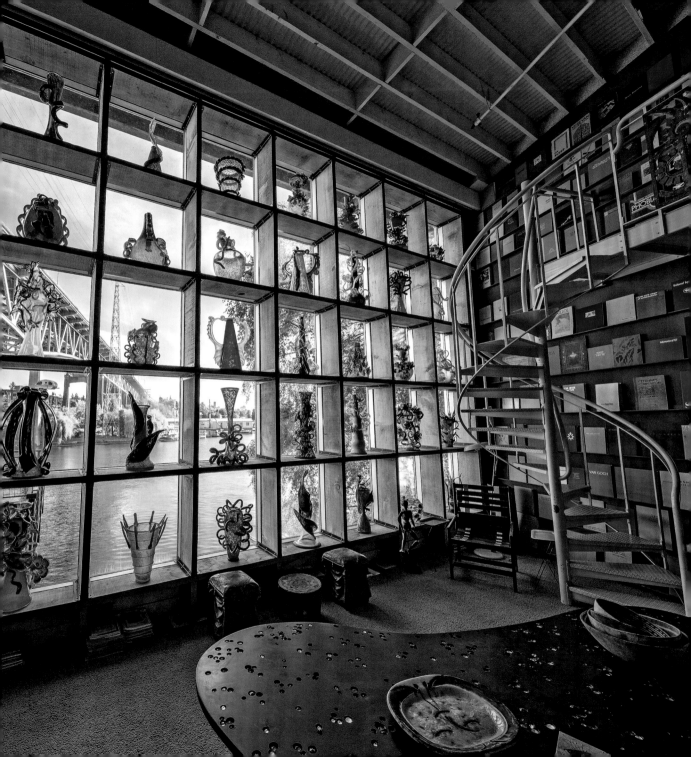

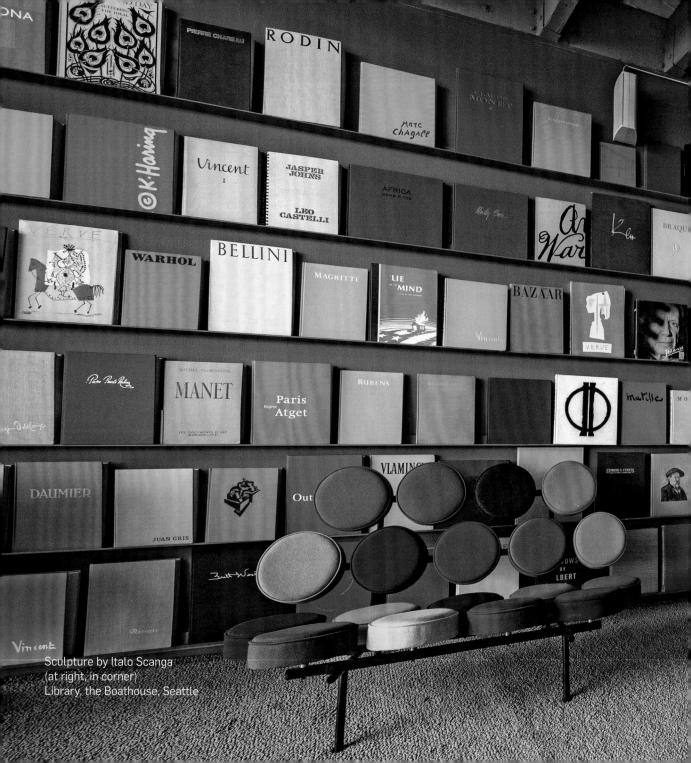

Sculpture by Italo Scanga
(at right, in corner)
Library, the Boathouse, Seattle

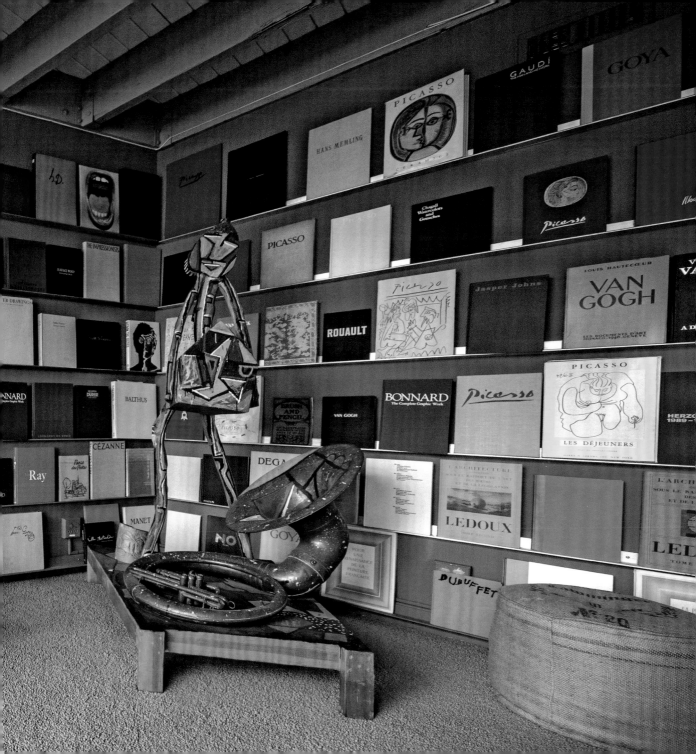

The Boathouse, Seattle

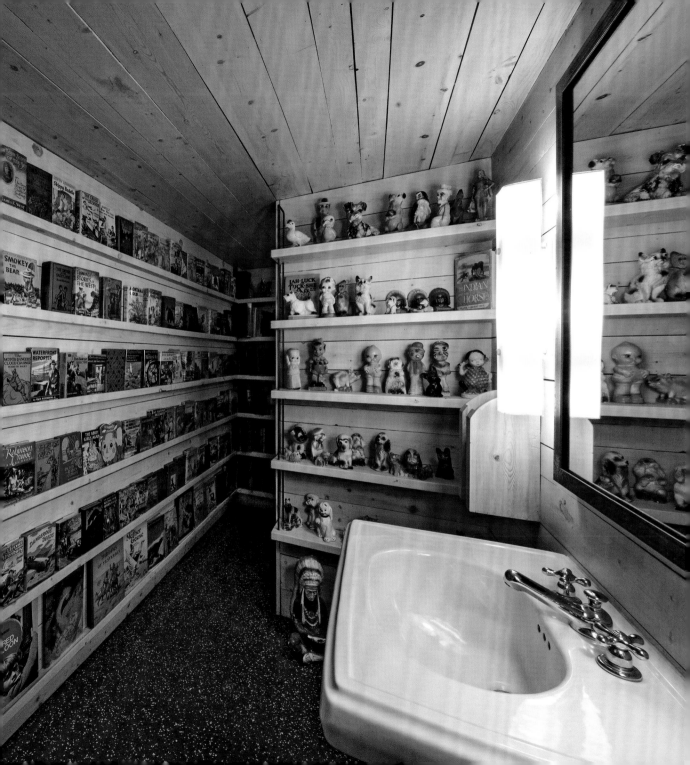

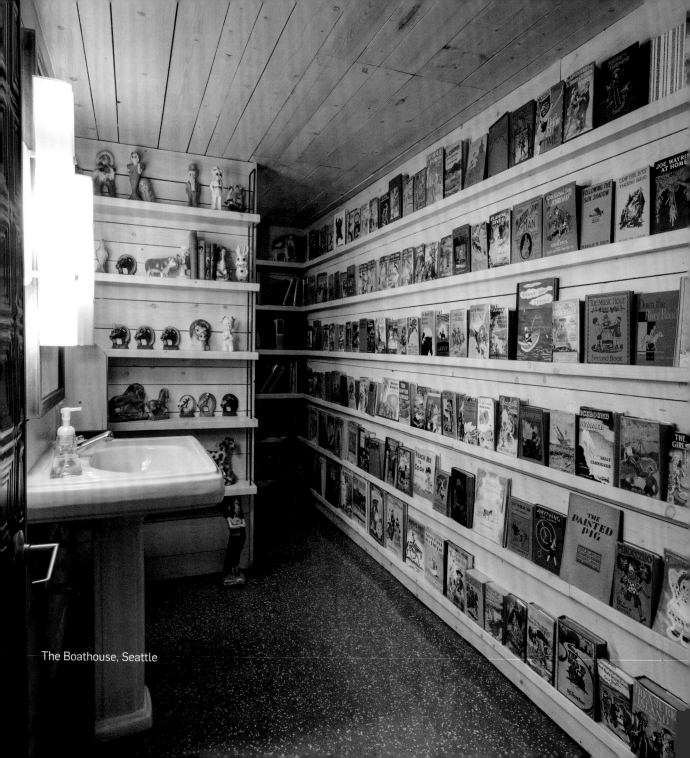

The Boathouse, Seattle

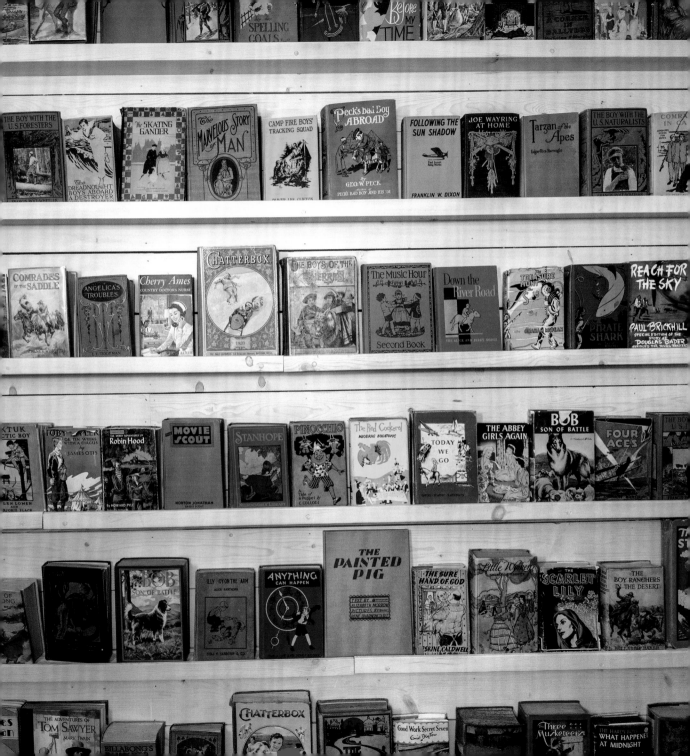

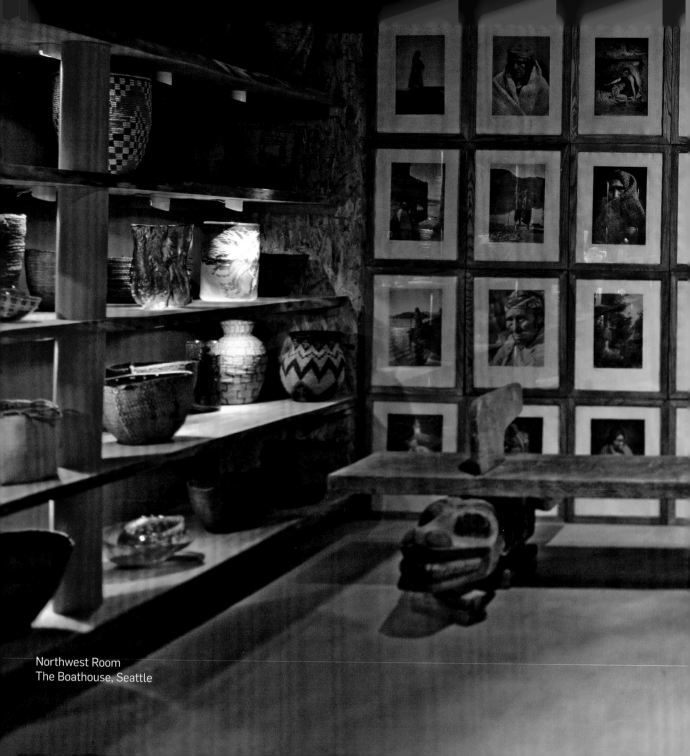

Northwest Room
The Boathouse, Seattle

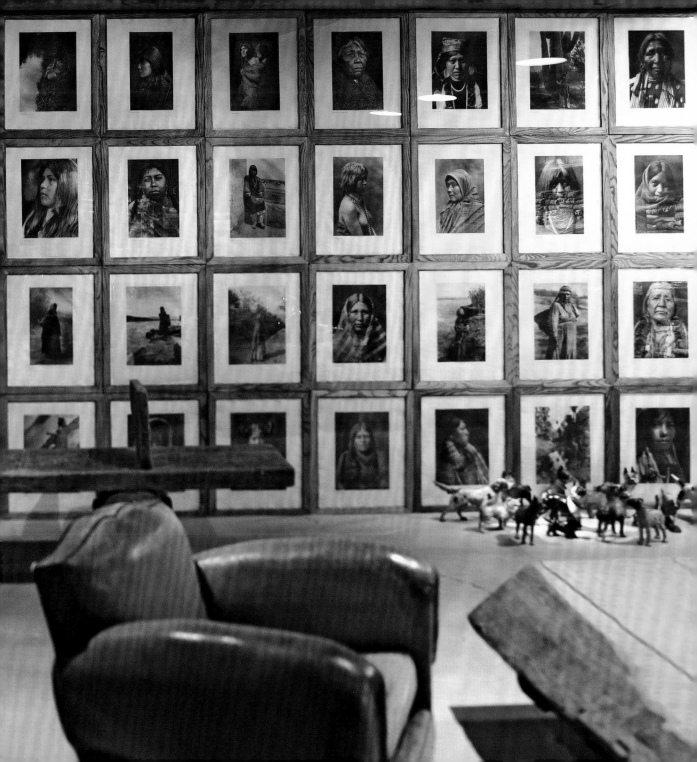

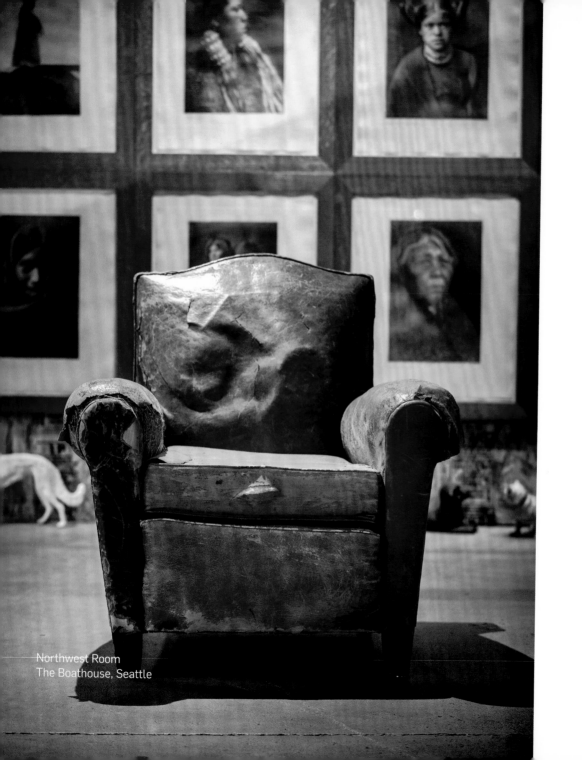

Northwest Room
The Boathouse, Seattle

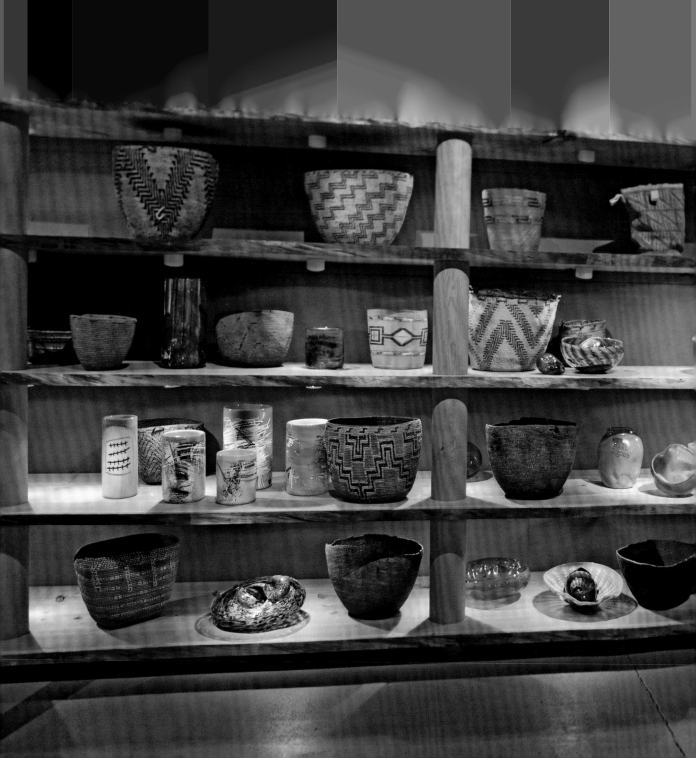

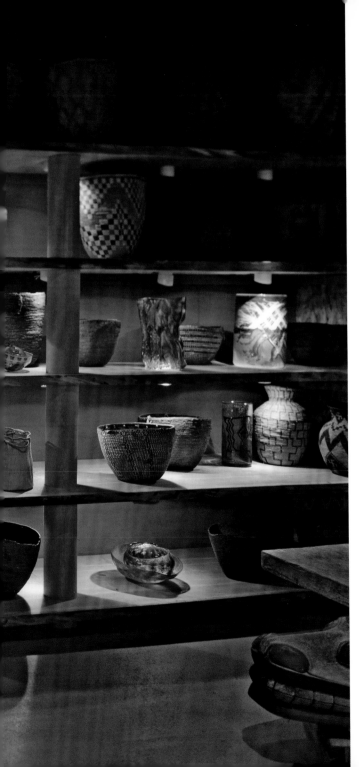

I got interested in the wonderful forms of Native American baskets in 1977, when I saw a collection in the Washington State History Museum in Tacoma.

Northwest Room
The Boathouse, Seattle

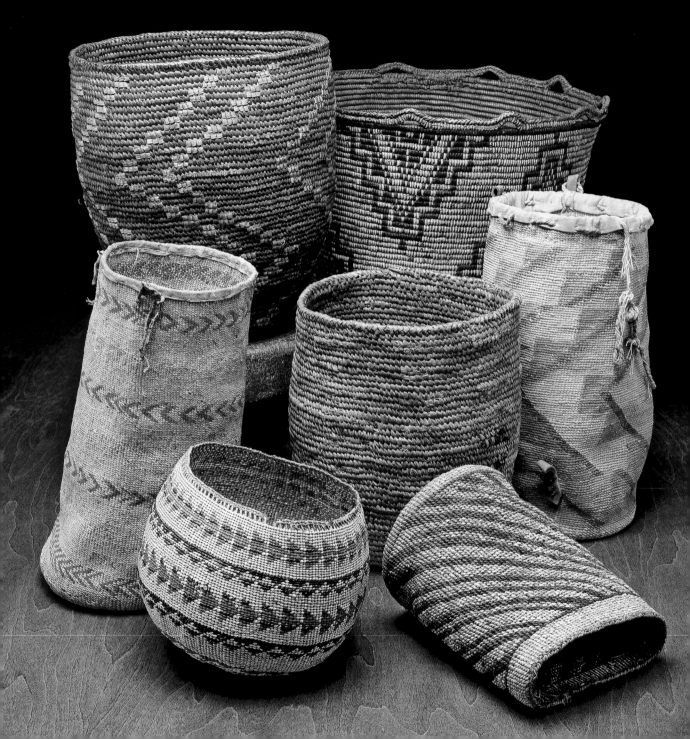

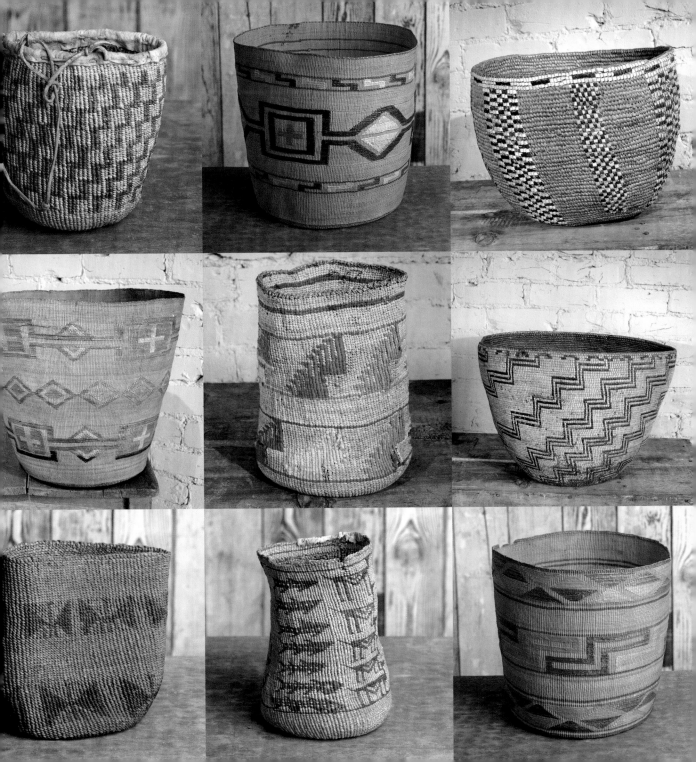

When I start to collect something, I often don't start with a single object. Sometimes I start with ten or twenty or a hundred. It is like creating my own little museum.

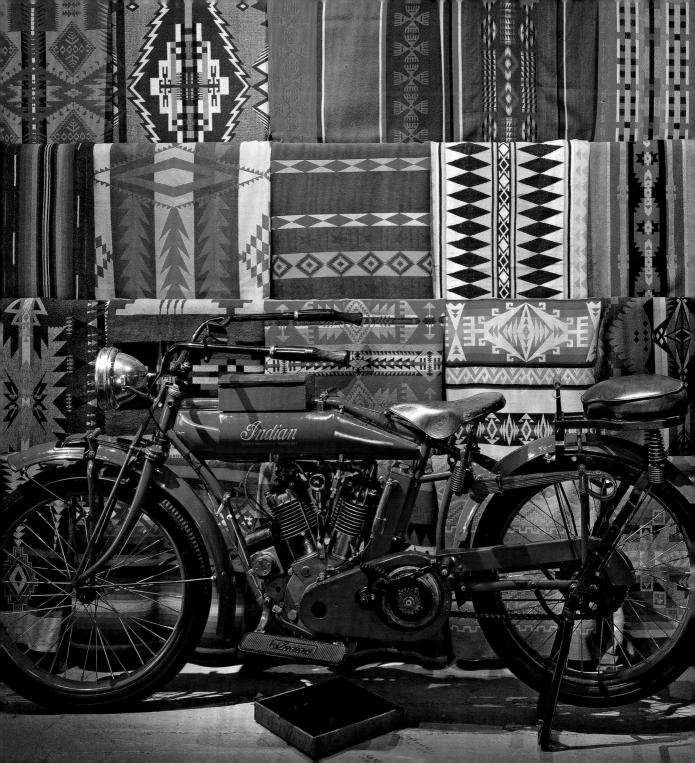

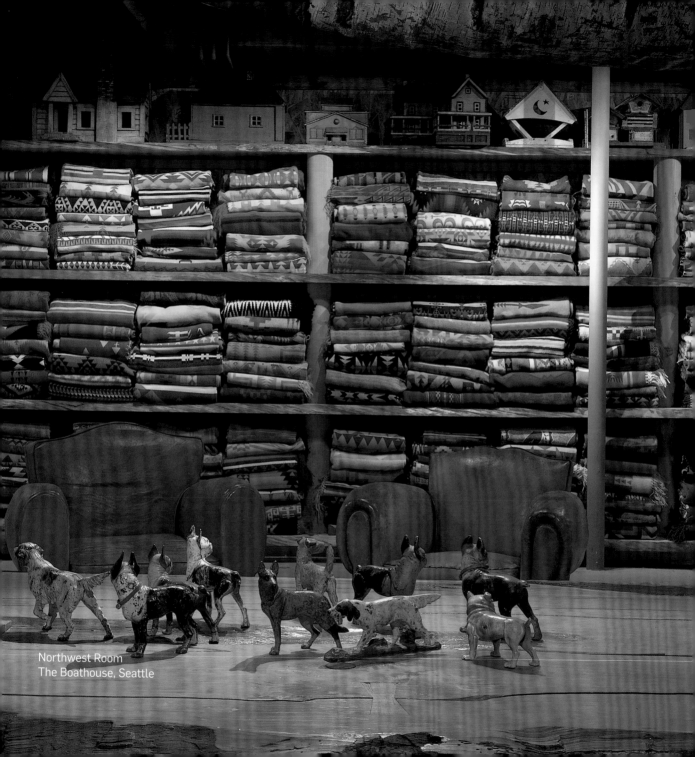

Northwest Room
The Boathouse, Seattle

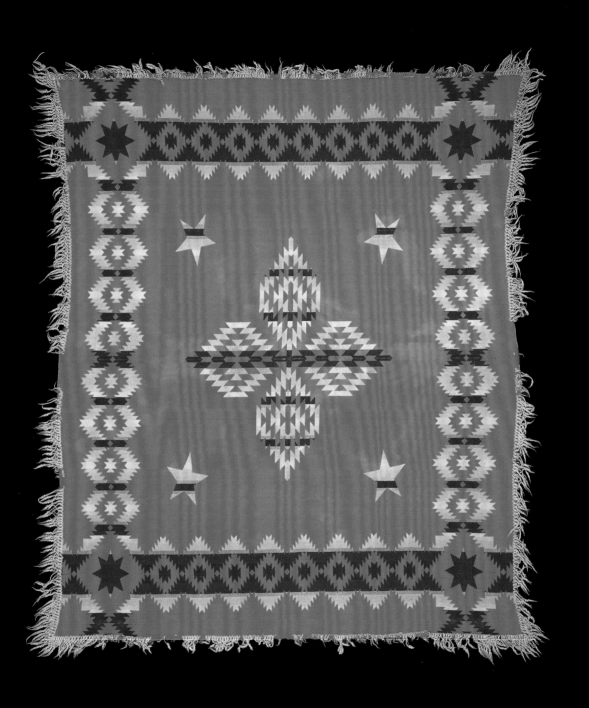

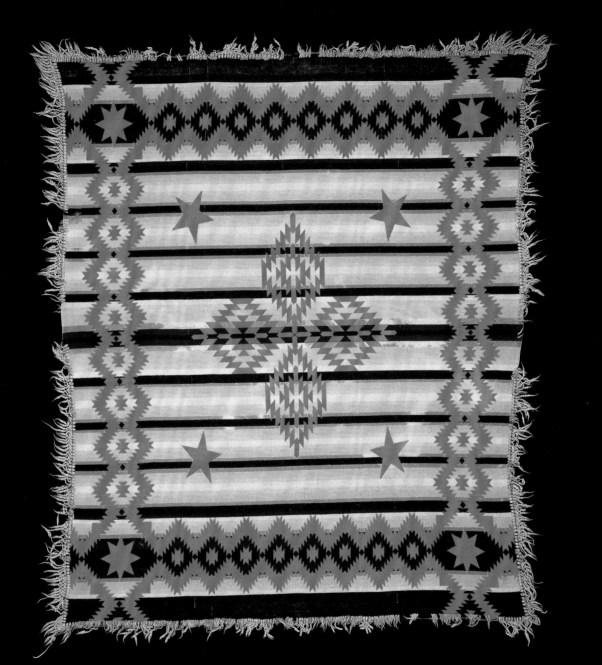

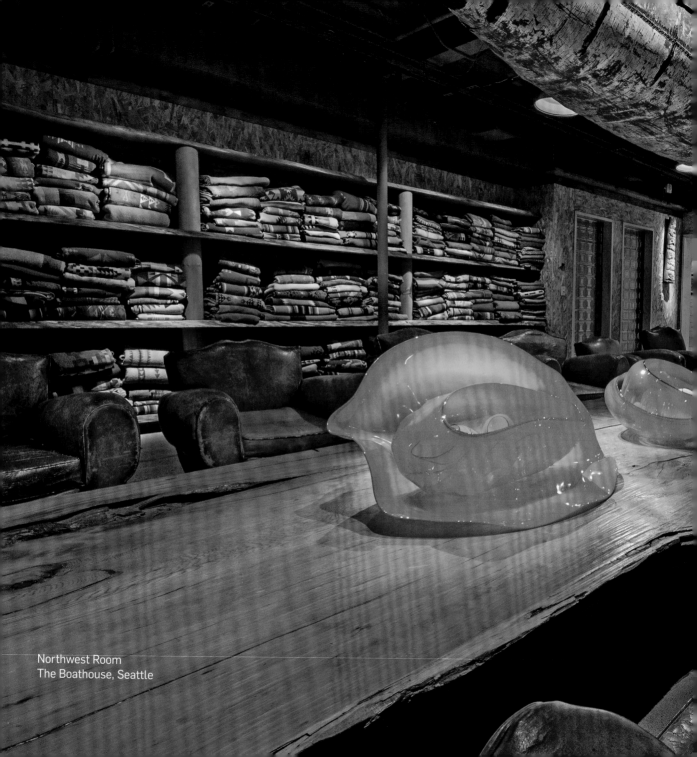

Northwest Room
The Boathouse, Seattle

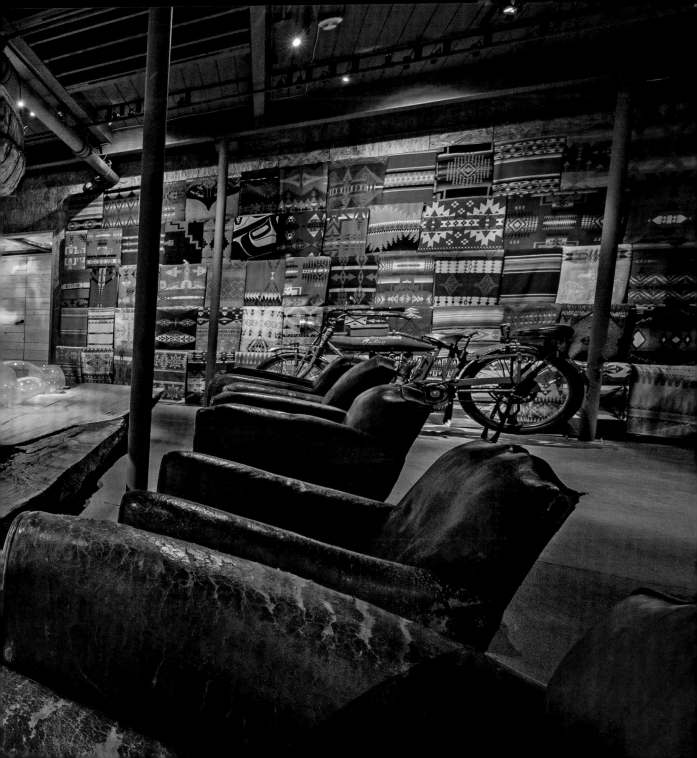

DALE CHIHULY

Born in 1941 in Tacoma, Washington, Dale Chihuly was introduced to glass while studying interior design at the University of Washington. After graduating in 1965, Chihuly enrolled in the first glass program in the country, at the University of Wisconsin. He continued his studies at the Rhode Island School of Design (RISD), where he later established the glass program and taught for more than a decade.

In 1968, after receiving a Fulbright Fellowship, he went to work at the Venini glass factory in Venice. There he observed the team approach to blowing glass, which is critical to the way he works today. In 1971, Chihuly cofounded Pilchuck Glass School in Washington State. With this international glass center, Chihuly has led the avant-garde in the development of glass as a fine art.

His work is included in more than 200 museum collections worldwide. He has been the recipient of many awards, including two fellowships from the National Endowment for the Arts and twelve honorary doctorates.

Chihuly has created more than a dozen well-known series of works, among them, *Cylinders* and *Baskets* in the 1970s; *Seaforms*, *Macchia*, *Persians*, and *Venetians* in the 1980s; *Niijima Floats* and *Chandeliers* in the 1990s; and *Fiori* in the 2000s. He is also celebrated for large architectural installations. In 1986, he was honored with a solo exhibition, *Dale Chihuly objets de verre*, at the Musée des Arts Décoratifs, Palais du Louvre, in Paris. In 1995, he began *Chihuly Over Venice*, for which he created sculptures at glass factories in Finland, Ireland, and Mexico, then installed them over the canals and piazzas of Venice.

In 1999, Chihuly started an ambitious exhibition, *Chihuly in the Light of Jerusalem*; more than 1 million visitors attended the Tower of David Museum to view his installations. In 2001, the Victoria and Albert Museum in London curated the exhibition *Chihuly at the V&A*. His lifelong fascination for glasshouses has grown into a series of exhibitions within botanical settings. The *Garden Cycle* began in 2001 at the Garfield Park Conservatory, Chicago, and continued at several locations, among them the Royal Botanic Gardens, Kew, near London, in 2005, and the New York Botanical Garden, Bronx, in 2006 and again in 2017. Meanwhile, Chihuly has exhibited at other venues as well, including the de Young Museum, San Francisco, in 2008; the Museum of Fine Arts, Boston, in 2011; the Virginia Museum of Fine Arts, Richmond, in 2012; the Montreal Museum of Fine Arts, in 2013; the Royal Ontario Museum, Toronto, in 2016; and the Crystal Bridges Museum of American Art, Bentonville, Arkansas, in 2017. In addition, *Chihuly Garden and Glass*, a major long-term exhibition, opened at Seattle Center in 2012.

Dale Chihuly with trade blankets and
Northwest Coast Native American baskets
The Boathouse, Seattle, 1992

COLLECTIONS

This book is able to show examples of only a selection
from Dale Chihuly's extensive and eclectic collections.
Here is a list of things that interest him:

Accordions
Alarm clocks
Appliances, Mid-century
 Blenders
 Refrigerators
 Stoves
 Televisions
 Toasters
Artwork
 by Edward S. Curtis
 by David Hockney
 by Michael Lawson
 by Stanislav Libenský
 and Jaroslava Brychtová
 by Pablo Picasso
 by Italo Scanga
 by Paul Stankard
 by Andy Warhol
 (among a number of other
 artists)
Automobiles
Barbed wire, Antique
Baseball mitts
Baskets
 Native American
 Wire
Belts, Horsehair
Bicycles, Vintage
Birdhouses and bird hotels

Blankets, Native American
 trade
 Buell Manufacturing Co.
 J. Capps and Sons
 Oregon City Woolen Mills
 Pendleton Woolen Mills
Board games
Bookends, Cast-iron dog
Books
 Architecture
 Art
 Children's
 Design
 Literature
 Poetry
Bottle openers
Bottles, Silvered
Boxes, Tlingit wooden
Cameras, Mid-century
Canoes
 Birch bark
 Willits Brothers
Carnival items
 Chalkware
 Masks
Chairs
 African bead
 Eames
 French club

Christmas ornaments,
 Vintage
Clothes, Vintage
Coffee carafes, Bauer
Curtains, Beaded
Dance-hall star lights
Dishes
 Atomic
 Fiestaware
Dogs, Ceramic
Dollhouses and dollhouse
 furniture
Doorknobs
Doorstops, Cast-iron
 Bouquets
 Dogs
Fire extinguishers, Antique
Fish decoys, Wooden
Fishing plugs
Floats, Japanese fishing
Fly-fishing reels and rods
Frisbees
Furniture
 Mid-century modern
 Patio
Glass
 Figurines
 Roman
 Venetian art

Glassblowing molds
Glass color rods
Halloween decorations
Hatboxes
Ice tongs
Inkwells, Silvered
Juicers, Glass
Lamps, Table and floor
Lampshades, Handblown glass
Lighthouses, Miniature
Luggage
Luggage labels
Lunch boxes
Mannequins, Antique
Marbles
Matchbooks
Mirrors, Venetian
Models
 Boats
 Cars
 Helicopters
Motorcycles
National Geographic
 magazines
Necklaces, African bead
Neon signs
Outboard motors, Vintage
Paintings, Indian miniature
Paperweights

Pez dispensers
Photographs
 Glass-lantern slides
 Prints
 35 mm slides
Picture frames, Wooden
Pocketknives
Postcards, Vintage
Posters
 Hand-painted carnival
 Movie
 War
Purses, Lucite
Racing shells, Pocock
Radios
 Mid-century
 Transistor
Record albums
Salt and pepper shakers
Shaving brushes
Shells
Shirts, Gabardine
Sombreros, Mexican silver
Speedboats
Sports equipment, Vintage
Stamps
Statues
 of Buddha
 Christian

String holders
Taxidermied animals
Tennis rackets
Textiles, Inca
Towel racks
Toys
 Cars
 Soldiers
 Stoves
 Tin
 Trailers
Walking sticks
Wristwatches
 Swatches

Additional photography and credits:

p. 2: Dale Chihuly in his 1957 Alfa Romeo Giulietta Spider automobile, Tacoma, Washington, c. 1960

p. 5: Chihuly and Italo Scanga, 1977

p. 6: Chihuly, Jackson, and Leslie Jackson in his 1938 Meteor, with Dale's 1947 Western Fairliner Torpedo in front. The 1935 MV *Kalakala* is in the background. Union Bay, Washington, 1999

p. 8: Shaving brushes

p. 11: Andy Warhol, *Dollar Sign*, 1981. © Artists Rights Society (ARS), New York. Italo Scanga, *For My Friend and Brother* © Italo Scanga Foundation. Christopher Makos, *Andy Glasses Four*, 1986. Christopher Makos 1981

p. 12: Pablo Picasso (1881–1973), *Bull's Head*, 1942. Assemblage, leather, metal, 33.5 x 43.5 x 19 cm. MP330. Photo: Béatrice Hatala. Musée Picasso, Paris, France. © RMN-Grand Palais / Art Resource, NY. © 2017 Estate of Pablo Picasso / Artists Rights Society (ARS), New York

p. 16: Two photos from *Raid the Icebox 1,* curated by Andy Warhol, Museum of Art, Rhode Island School of Design, April 23–June 30, 1970. Courtesy of the Museum of Art, Rhode Island School of Design, Providence

pp. 100–101: Stanislav Libenský and Jaroslava Brych-tová, *Queen III*, 1988–92; *Arcus II*, 1992; *Green Eye of the Pyramid I*, 1993; *Queen I*, 1987–88

pp. 142–43: "Hohner" is a trademark of HOHNER Musikinstrumente GmbH.

pp. 154–55: Italo Scanga, *Figure (House and Tuba)*, 1986 © Italo Scanga Foundation

Endpapers: Birch bark canoe (detail)

For complete information on photo credits in this book, please e-mail: info@chihulyworkshop.com.

Special thanks: Scott Mitchell Leen & Team Chihuly
Project Editor: Mark McDonnell
Designer: Goretti Kaomora
Executive Consultant: Leslie Jackson Chihuly
Archivist: Ken Clark
Copy Editor: Richard Slovak

Photographers: Theresa Batty, Dale Chihuly, Jan Cook, Jack Crane, David Emery, Claire Garoutte, Scott Mitchell Leen, Teresa Rishel, Terry Rishel, John Snekser, Nathaniel Willson

Typeset in Typewriter by A-2 TYPE and Flama, Feliciano Type Foundry

Dale Chihuly is considered one of the most innovative and iconic figures in contemporary art. Chihuly has been working with glass as an artistic medium for more than fifty years, to increasing critical and popular acclaim. His solo exhibition venues have included the Victoria and Albert Museum, London; the de Young Museum, San Francisco; the Museum of Fine Arts, Boston; and the Montreal Museum of Fine Arts. His work is in the permanent collections of more than 200 museums worldwide.

Bruce Helander is an artist who also writes about art. A regular contributor to the *Huffington Post* (now *HuffPost*), *Sculpture*, and *ForbesLife*, he is a former White House fellow of the National Endowment for the Arts and the former editor-in-chief of the *Art Economist*. He is also a former provost and vice president for academic affairs at the Rhode Island School of Design, where years earlier, as a freshman, he first met Dale Chihuly.